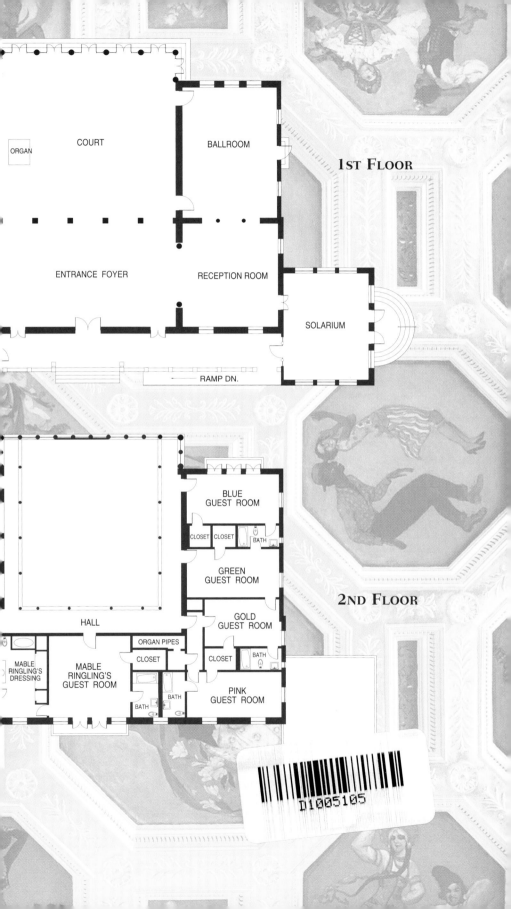

1ST FLOOR

ORGAN

COURT

BALLROOM

ENTRANCE FOYER

RECEPTION ROOM

SOLARIUM

RAMP DN.

2ND FLOOR

BLUE
GUEST ROOM

CLOSET CLOSET BATH

GREEN
GUEST ROOM

GOLD
GUEST ROOM

HALL

ORGAN PIPES

CLOSET

CLOSET BATH

MABLE
RINGLING'S
DRESSING

MABLE
RINGLING'S
GUEST ROOM

BATH

BATH

PINK
GUEST ROOM

Cà d' Zan

INSIDE THE
RINGLING MANSION

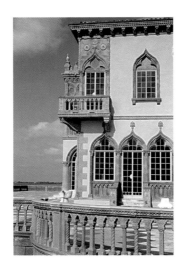

Printing and Separations by Serbin Printing & Publishing, Inc.,
Sarasota, Florida
Robin K. Clark, Project Director
Judy Webster, Designer
Michael Hamel, Color Separations
Jim Keen, Production Manager

All new photography by Giovanni Lunardi Photography, unless otherwise listed.
All historic photographs found in the Museum Archives

PUBLISHER'S CATALOGUING-IN PUBLICATION DATA

De Groft, Aaron H., 1965–
Cà d'Zan: Inside the Ringling Mansion / Aaron H. De Groft and David C. Weeks–
Sarasota FL: The John and Mable Ringling Museum of Art, 2004.
72 p.: ill.; 23 cm.
Includes bibliography.
1. Cà d'Zan (Sarasota, Fla). 2. Ringling, John, 1866–1936–Homes and
haunts–Florida–Sarasota. 3. Ringling, Mable, 1875–1929–Homes and
haunts–Florida–Sarasota. 4. The John and Mable Ringling Museum of Art.
I. Title. II. Weeks, David Chapin.

N 742 .S5 A8 2004 728.8'09'759'61-dc21 ISBN 0916758478

Library of Congress Control Number 2004090501

Front Cover
Cà d'Zan at sunset

The John and Mable Ringling Museum of Art
Dr. John Wetenhall, Executive Director

Florida State University
Dr. Thomas Kent "T.K." Wetherell, President

Contents

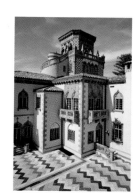

A s the grand and elegant landmark of the State Art Museum of Florida, a building as magnificent as Cà d'Zan would surely stand atop any priority list for historic preservation. It did not. As decades of moist, salty winds off Sarasota Bay eroded the structure, under-funding led to year upon year of deferred maintenance. Fabrics faded. Water seeped through leaky roofs. Railings collapsed. Glass cracked.

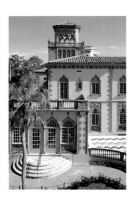

The marble terrace was in such disrepair that it was dangerous to visitors to even walk upon it. In 1996 Cà d'Zan offered the central setting for a film adaptation of Dickens' *Great Expectations*, as the once-sparkling palace of the Ringlings had now degenerated into the decrepit ruin of Ms. Havisham.

By the mid-1990s, the threat of forever losing Cà d'Zan forced the State of Florida and private donors to redress the building's ailing health. Funds were raised to repair the Venetian Gothic structure, conserve original furnishings, restore walls to their original colors, conserve paintings, refurbish floors, replace worn fabrics, install new climate and security systems, and plant trees, flowers, and verdant shrubs.

In the process, we also discovered that the look of the mansion had been repeatedly altered and changed, so that the entirety no longer reflected original taste. Layers of wall paint were examined to determine each original color, while vintage photographs and written accounts were studied to measure historical accuracy. In other words, we restored the home to its original state, past the taste of former directors, back to the era of Mable Ringling.

In 2000, governance of the Ringling Museum was transferred from Florida's Department of State to Florida State University, and a new Board of Directors was appointed to see the restoration to completion. In April of 2002, after six years of restoration and three long years of closure, Cà d'Zan reopened to record crowds. The grace and imaginative charm of this Roaring Twenties vision came back to life, to the delight of tourists from around the globe.

We hope this brief history heightens your pleasure in the splendors of Cà d'Zan, and sparks in your imagination the fantastical wonders once conceived by John and Mable Ringling.

John Wetenhall, PhD.
Executive Director, The Ringling Museum of Art

T here is much up-to-date research and new understanding regard-
ing John and Mable Ringling and their life at Cà d'Zan. Thanks
must go to many museum colleagues, especially Françoise Hack and
Linda McKee, who made enormous contributions to this book.
Without the support and focus of all the staff of the Ringling, the
splendor of the Cà d'Zan would not be what it is today.

Research and writing is built upon the foundations of those who
served as curators and researchers in the past. Beginning with the first
guidebooks to the Cà d'Zan by first director, A. Everett "Chick" Austin,
Jr. and Marian Murray, to the popular overall guide to the Ringling by
Patricia Ringling Buck, insights and interpretations evolve and change
as new findings are uncovered. The most surprising treasure trove of
information came from one of the most unlikely of sources, that of the
online auction company, eBay. In 1999, Museum Curatorial and
Library staff, Françoise Hack and Linda McKee acquired for the
Ringling a set of about fifty, black and white construction photographs
that document the building of the Ringling mansion. The pictures
were taken in 1925–26 by Harold W. Woodill, the
Portland Cement superintendent at the construc-
tion site. All the photos were fully dated on the
negative. This was a boon to the understanding of
the history of the great mansion.

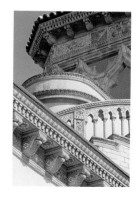

DEDICATION

T his book is dedicated to Dr. David Chapin
Weeks (1919–2003). As this publication was
finalized, Dr. Weeks, co-author, passed away unex-
pectedly. He had a long and outstanding service to
the Ringling for over twenty years. He served as a docent, supporter,
spokesman, and a research historian in the Archives of the Museum,
a repository that Weeks originated and built. Dr. Weeks developed the
historic understanding that the Museum has today regarding the life
of John and Mable Ringling and their impact on the community.
Dr. Weeks was respected and beloved by his colleague docents and
by the Ringling staff. He will long be remembered as the author of the
authoritative text on John and Mable Ringling, *John Ringling: The
Florida Years, 1911–1936*, published by the University of Florida Press.
He was a special, personal friend to me and I miss him greatly.

Aaron H. De Groft, PhD.
Curator, The Ringling Museum of Art

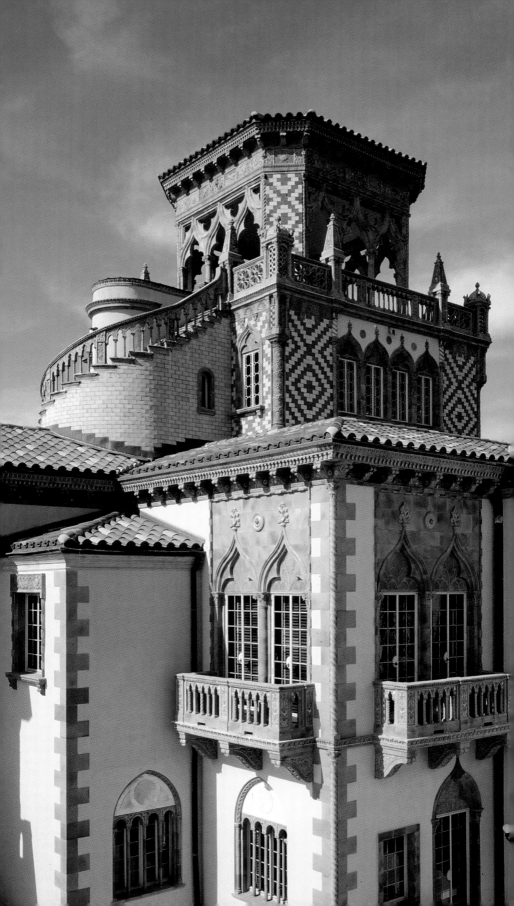

INTRODUCTION

E xotic Cà d'Zan emerges along the sparkling Gulf waters of
Sarasota Bay, Florida. Remarkable in its architecture and resplen-
dent in its biscuit stucco façade and roof of multi-hued, Spanish tiles,
the palazzo evokes the richness and glory of Venice, Italy.

This was the winter home of one of the foremost figures in the
American entertainment industry, the legendary Circus King, John
Ringling and his wife, Mable Burton Ringling. Since 1926, Cà d'Zan
has offered guests and visitors a rare glimpse of the personalities and
passions of its owners. It stands today as a luminous testament to the
private lives of these remarkable people.

• • •

The Ringlings first visited Sarasota, Florida in 1909. Two years later
they bought a frame clapboard house situated on nearly twenty acres
of a large estate belonging to Charles N. Thompson, a manager with
Buffalo Bill's Wild West Show. Here, at Palms Elysian, they enjoyed
their unpretentious Sarasota Bay-front home until changes in their
tastes and ambitions led to the need for a more impressive new
mansion. To this end, the Ringlings added to their land holdings by

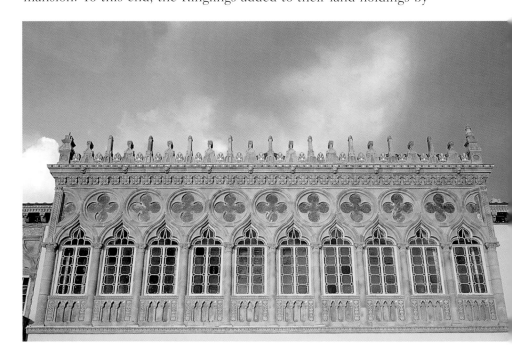

West façade

1

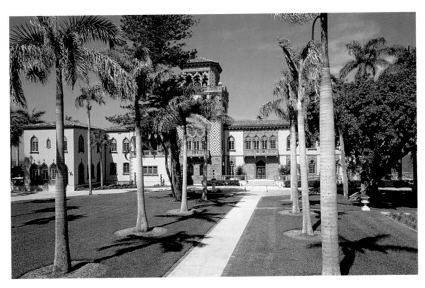

East exterior and detail

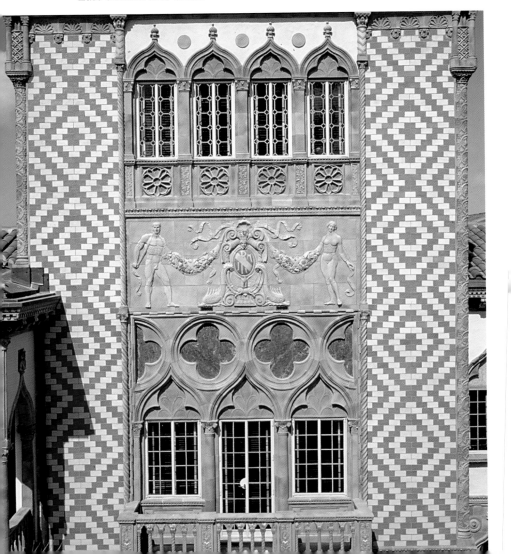

acquiring two smaller parcels that enlarged their estate to thirty-six acres. In fact, pent up wealth from the war years was pouring into Florida as Americans pursued the dream of a paradise in the sun. All around Florida, architects were promoting the Mediterranean style for fashionable homes. But the Ringlings were not satisfied with the routine fashion of the day.

In 1924, the task of designing a house that would satisfy both Mr. and Mrs. Ringling passed from one architect to another. The final choice, Dwight James Baum of Riverdale, New York, possessed the vision and technical skill necessary for the novel ideas the Ringlings had in mind for a house that would embody the whimsical and the grand. The couple had traveled extensively throughout Europe, and while John scouted for circus acts and collected art for his museum,

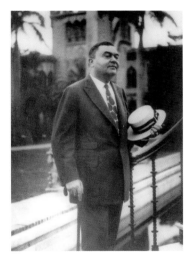 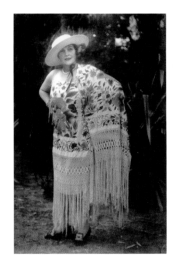

John and Mable Ringling, ca. 1927

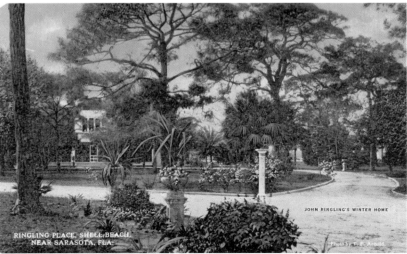

Historic postcard of Palms Elysian, 1919

3

Mable acquired an abiding passion for all things Venetian. As the primary architect, Baum, along with his architectural engineers, Lyman Dixon and Earl Purdy, set out to design a Venetian palazzo with all the comforts and modern conveniences of a mid-1920s American home.

Baum was aware that rich Americans wanted everything that current invention could supply in appliances, heating, light, and comfort. Intrigued by the opportunities available in Florida, he opened a full-time Sarasota office in the same building that housed John Ringling's island enterprise and the construction company owned by Owen Burns. Burns would serve as the builder and construction manager for Cà d'Zan, and while archival correspondence on the project is entirely between John Ringling and Owen Burns, the day-to-day discussions were between Dwight Baum and Mable Ringling. Though Cà d'Zan may translate from Venetian dialect into "The House of John," the project was always listed on Baum's plans as "the home of Mrs. John Ringling, Sarasota, Florida."

The aristocratic Baum was never certain that Cà d'Zan was more than a capricious, even fantastic eccentricity. A true Venetian house

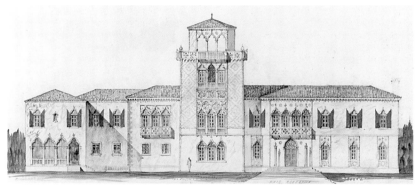

Early watercolor elevation of East exterior, ca. 1924

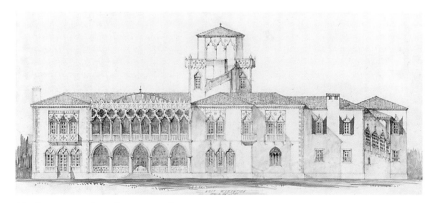

Early watercolor elevation of West exterior, ca. 1924

was a townhouse, standing side-by-side with its neighbors, fronting a canal. Although the exterior style of Cà d'Zan is graced with Venetian Gothic details, many aspects of the design reveal the influence of the French academic tradition. Baum had studied architecture at Syracuse University, which, like most American design schools at the turn-of-the-century, followed the basic curriculum and philosophy of the French École des Beaux-Arts in Paris. That system emphasized a floor plan that permitted free circulation around a focal central space (such as the Court at Cà d'Zan), with important "public" rooms (such as the Ballroom and Dining Room) located around this. The less "ceremonial" and more functional rooms were placed further away from the

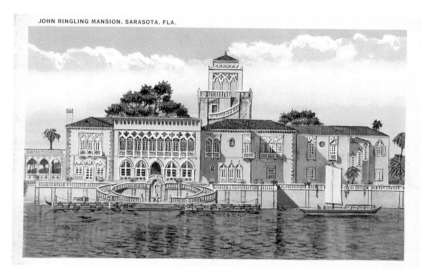

Historic postcard depicting evolving design of west exterior, ca. 1924

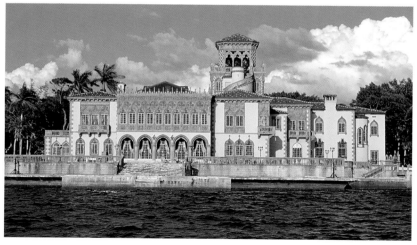

View from the Bay

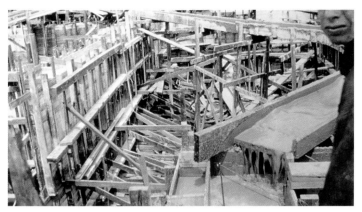

Pouring of the foundation, 1924

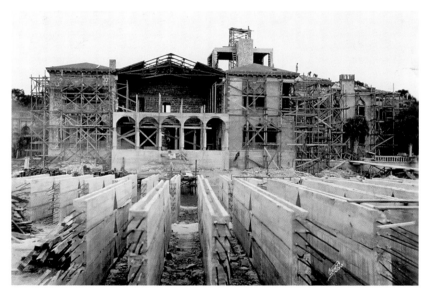

Construction of the Terrace and West façade, ca. 1925

center, in a hierarchical arrangement. Cà d'Zan, however, was to be a country house, standing on more than thirty acres of grounds. The conflict between the design and the Florida location presented immediate dilemmas to the task of designing a house that would meet Mable Ringling's ever-changing requirements.

The meetings between Baum and Mable were often heated as she demanded many changes to his plans. The construction of Cà d'Zan was well underway before Baum, in an effort to stop the mounting costs of Mable's alterations, changed the terms of his agreement from a fixed fee to one based on time-and-materials.

In the end, the compromises were clearly visible: the view from the approach presented an orderly, proportioned façade, with an off-

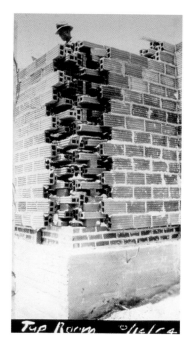
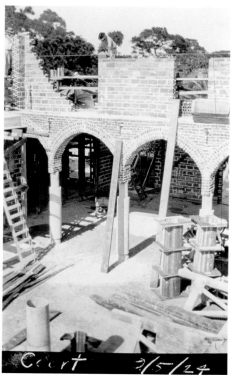

Terracotta "T" blocks interlock to form the walls, 1924

Construction of the Court in masonry, cement and "T" blocks, 1924

center tower. The diaper pattern of the glazed tiles on the tower walls and the *ogee* shape of windows suggest Venetian antecedents. On the waterside, it appeared as if two Grand Canal, palace-type hotels of Venice served as models. The interior of the Danieli and the exterior of the Bauer-Grünwald offered features adaptable to a Florida mansion. Even some of the specific architectural vocabulary of the Doge's Palace—such as some of the details on the Tower and the windows—could be seen in Cà d'Zan. Yet visitors to the mansion must have been awestruck by the work of the artists who fashioned the wealth of symbols on the exterior. It is the details such as the *sgrafitti* (low-relief decoration) above the windows, the Zodiac symbols that ring the roof of the Tower, the Masonic symbols on attached columns on the Tower and Louis XIV sunflowers under the eaves, among many others, that gave Cà d'Zan its distinct and unusual aura of historic, eclectic splendor.

Cà d'Zan was—and still is—a truly exceptional house; an original and unique Florida residence designed, built, and lived in, almost wholly in a single decade from the mid-Twenties to the Depression

Next page: Belvedere of the Tower with Zodiac decorations

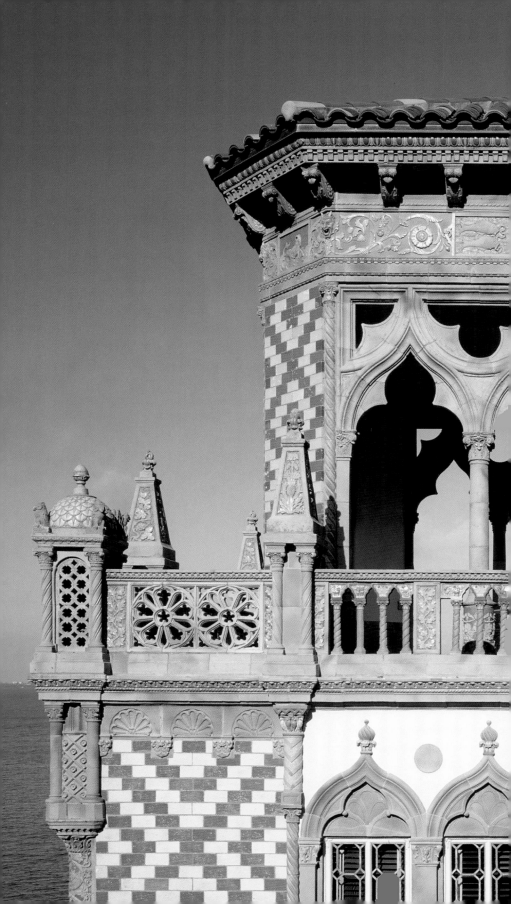

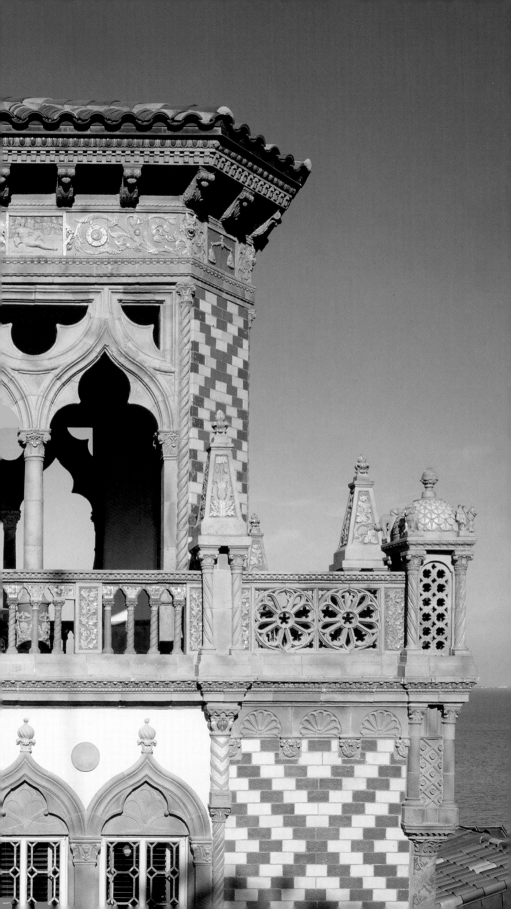

years. The house reopened in the spring of 2002 after six years of major restoration that demanded an immense, dedicated effort carried out by a team of Museum staff, artisans, craftsmen, and conservators. Their collective talents have re-created the brilliant ambience of the early years of the mansion in the Roaring Twenties, recounting a way of life that has faded almost beyond recognition.

Renewal also has brought with it a new life and a new future for this great house. Visitors now have the opportunity to rediscover the craftsmanship and ingenuity that made possible the Ringlings' architectural fantasy. The home designed for the Ringlings is now in every sense a great historical house, a showcase mansion restored to its original magic with fresh color and majestic display.

WELCOME TO CÀ D'ZAN

The Gatehouse and the Ringling estate

The guests of Cà d'Zan were chauffeured from the Atlantic Coast Line Rail Road Station in one of Mr. Ringling's Rolls Royce or Pierce Arrow limousines. Their first view of the estate was The Gatehouse. This arched structure, also designed by Dwight Baum, was large enough to accommodate the gatekeeper, and marked the beginning of the long, heavily shaded entrance road to the house.

John Ringling was intensely interested in the many strange trees and plants found in Florida. Ultimately, the estate landscaping included more than four hundred plant varieties. Among them are the

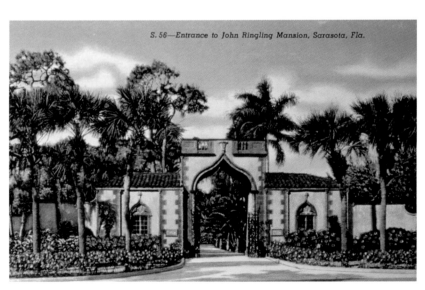

S. 56—Entrance to John Ringling Mansion, Sarasota, Fla.

Historic postcard of Cà d'Zan Gatehouse, ca. 1926

Lush grounds as shown in historic postcard, ca. 1927

famous Banyan trees, traditionally reported to have been gifts of Thomas Edison from his nearby estate in Fort Myers. The one-third-mile drive through the carefully tended semi-tropical landscape engendered a feeling of romance as the limousine passed through displays of exotic palms and flowering shrubs, interspersed with putto statues brought from Italy.

Upon reaching the circular drive at the east entrance of Cà d'Zan, guests were welcomed by Ringling's butler, Frank Tomlinson, a gentleman who served the Ringlings for many years and who presided over the mansion and its seven servants.

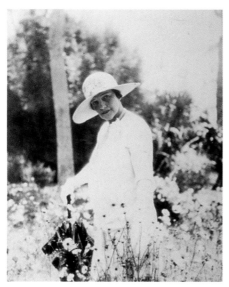

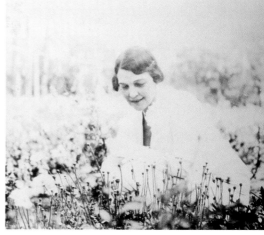

Mable Ringling in her Sarasota gardens, ca. 1925

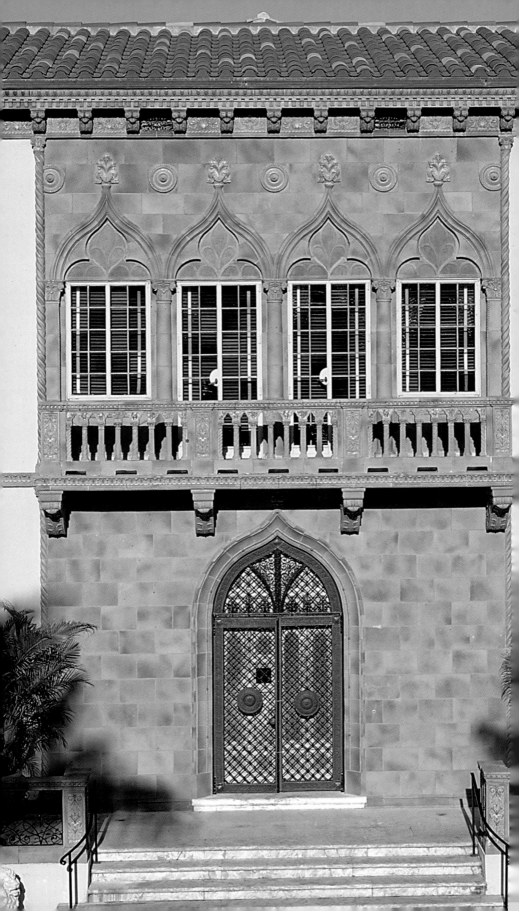

Entrance and Foyer

The front steps of the house are paved with beautiful purple Formosa marble from Germany. A copper and wrought iron screen designed by Baum covers the weathered walnut of the Renaissance-style great front door. Inside, the door is faced with polished mahogany.

As the first room guests enter, the Foyer makes a striking impression, reflecting the great showman-capitalist and his wife. Their hearts were captured by the charms of Italy—particularly Venice, and the Foyer sets a tone of formality and Venetian atmosphere for the rest of the ground floor rooms. Having seen the richness, dignity and beauty of Italian workmanship in the palaces that lined the canals of Venice,

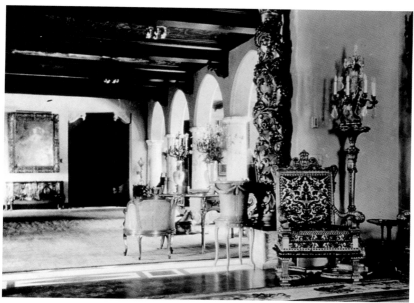

View into foyer, ca. 1927

the Ringlings sought to replicate these details with faux-travertine marble walls, pointed-arch or *ogee* windows, and slender brick, onyx-faced columns. Robert Webb, Jr. (1897–1986), a student of American society-portraitist John Singer Sargent, was the principal painter in charge of decorating the ceilings, and his work can be seen throughout the house.

The Ringlings were also greatly influenced by the moneyed prestige of the American Gilded Age. They knew the elegance of the best American furnishings, and they would be satisfied with nothing less than the best on Sarasota Bay. One of the most striking aspects of the

Front entrance

Foyer is the array of carved and gilded throne chairs purchased by the Ringlings at the estate sale of railroad owner George Jay Gould (1864–1923) at Georgian Court in Lakewood, New Jersey. Made and signed by H.E. Hall, and upholstered with European-loomed, Italian, cut velvet, these chairs with footstools face a pair of Italian *cassone*, or wedding chests, and two large, Flemish, seventeenth-century tapestries.

The Ringling collections include more than twenty tapestries; most are Flemish, seventeenth century, or those of French seventeenth and eighteenth-century origins. At one time, nine were hanging in Cà d'Zan, conveying a rich, continental air to the noble rooms. A pair hangs as they were placed in 1926, on either side of the front door. On the right is *Carlo and Ubaldo* (characters from Tasso's epic poem, *Jerusalem Delivered* of 1581), and on the left is *Adonis Starting for the Hunt, with Venus and two Putti.*

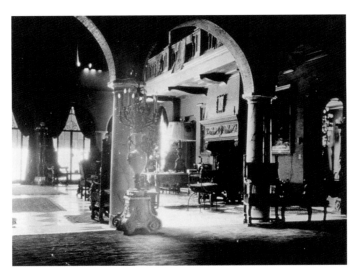

Foyer with view into Court, ca. 1927

Straight ahead from the Foyer, the view to the Court presents an unusual combination of luxury, comfort, and welcome to guests. Two large onyx and gilt bronze ormolu torchères, made to look like great vases of gold flowers, are from the Henry Hilton mansion on 7 West 34th St. in New York. These furnishing were made by E.F. Caldwell & Co., a New York firm known for its elegant lighting fixtures that rivaled Tiffany and Co. in quality and appeal.

Beside the entrance to the Dining Room, John Ringling originally hung the seventeenth-century portrait of Marianna of Austria, second wife, niece, and cousin of King Philip IV of Spain. When Ringling purchased the large canvas it was attributed to Diego Velázquez. It is now attributed to Velázquez's son-in-law, Juan Bautista Martinez del Mazo. Beneath the portrait is a reproduction of a Louis XIV coin cabinet. Its

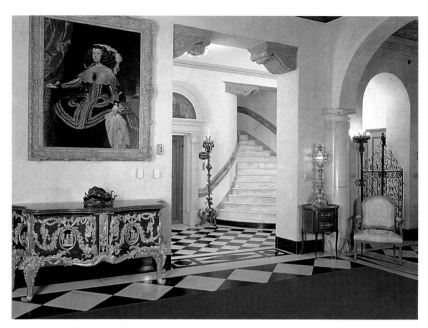

View towards Grand Staircase

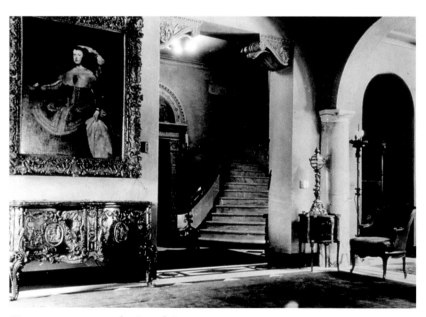

Historic view towards Grand Staircase, ca. 1927

marquetry and gilt bronze ormolu mounts make it a suitable addition to a room of such surpassing elegance.

While the Foyer was the room Baum intended to be the living room, it was better suited as an entrance. It was sometimes used by Mable Ringling for card-party luncheons, and it provided ample open space for crowded receptions.

Reception Room

Large gilded wood, twisted (or Solomonic) columns mark the entrance to a smaller reception or sitting room. The partners desk which occupies the center of the room was often moved aside to expand the adjoining Ballroom when dancers needed the space. At one point, at the far end of the Foyer in the Reception Room, John Ringling placed Bartolomé Estaban Murillo's *Immaculate Conception* altarpiece, painted for the Cathedral in Lima, Peru. Mr. Ringling, who rarely spoke of his collection, once said that owning the Velázquez Marianna and the Murillo gave him great pleasure. One of the Ringlings' prized rugs, a Persian rug with a "Tree of Life" pattern, which once covered the teak floor of the Reception Room, now hangs on the wall. The

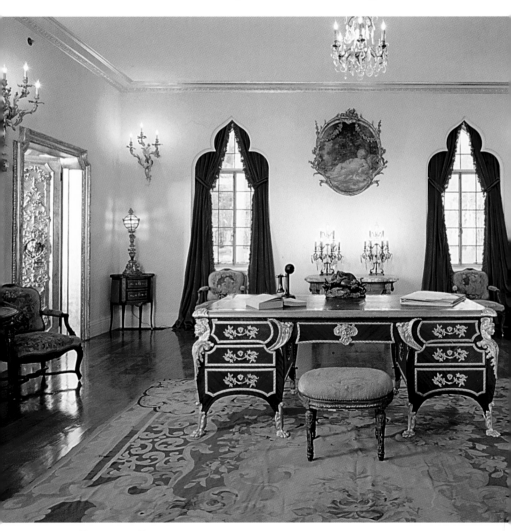

Reception Room

fine, glazed, gilded wood, three-paneled screen, probably designed and made by the Parisian firm of Jules Allard et fils, separates the Reception Room and the Ballroom.

PLEASE, BE OUR GUESTS

Solarium

A carved, gilded door leads from the Reception Room to the Solarium. Once an open porch, it was enclosed before 1931, in John Ringling's lifetime. The glazed windows protect the room from weather and mosquitoes. Because it was close to the swimming pool in the front lawn, the Solarium served as a convenient retreat. It afforded indoor-outdoor informality and access via the front terrace of Cà d'Zan or by a

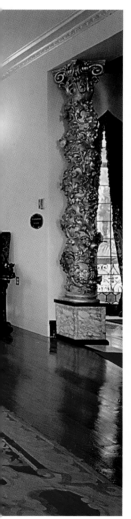

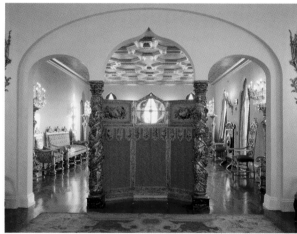

View of Reception Room towards Ballroom

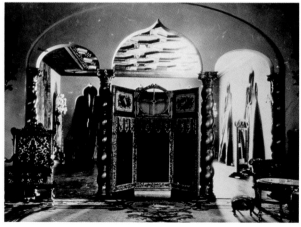

Historic view of Reception Room towards Ballroom, ca. 1927

north entrance of *demi-lune* (literally "half-moon") or semi-circular marble steps. The decoration of the room was changed often according to Mrs. Ringling's direction. Originally, a blue-tinted plaster covered the ceiling and a "Pompeiian," or scumbled, finish covered the walls. Mable Ringling, however, made many changes to various wall treatments and evidently, very soon after its completion, had the Solarium altered to include a Venetian-inspired ceiling border created by Webb. His signature and date of 1925 were found in the border in 2001.

Mrs. Ringling added to the Venetian atmosphere of Cà d'Zan when she bought a gondola that she moored on an island situated a few yards off the west terrace. Owen Burns made the island when he dredged a yacht channel for the lower terrace dock at the Ringling home. A hurricane later destroyed both the island and the gondola; however, in

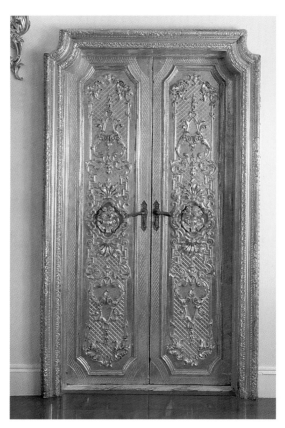

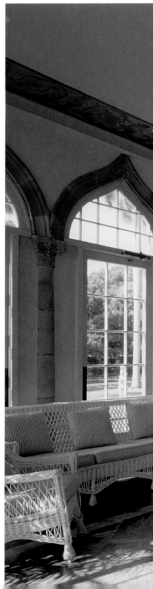

Gilded doors to the Solarium Solarium

the Solarium visitors can see a model of both the gondola and Mr. Ringling's yacht, *Zalophus*, which means sea lion in Latin. While on loan to Mr. Ringling's friend Sam Gumpertz, who entertained New York Mayor Jimmy Walker and his friend Betty Compton, *Zalophus* sank in Sarasota Bay on February 4, 1930. All escaped without injury.

The Ballroom

Cà d'Zan was designed as much for entertaining as for daily living. As John Ringling sought investors for his local real estate development deals, he shared his vision of the good life in Sarasota by entertaining in his Ballroom, Dining Room, Tap Room, Court, and Game Room.

Next page: North view with demi-lune steps to the Solarium

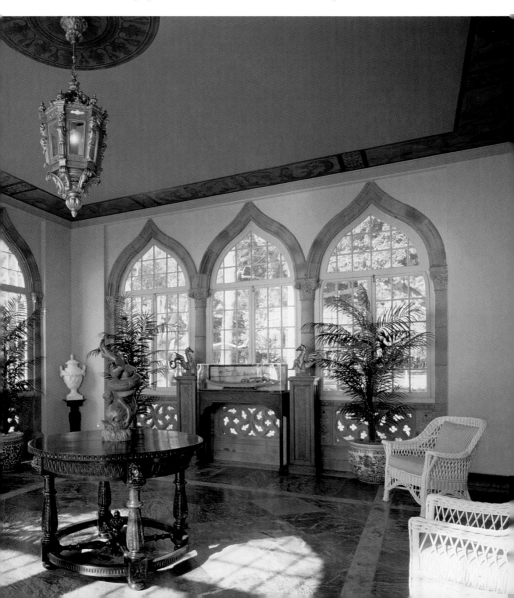

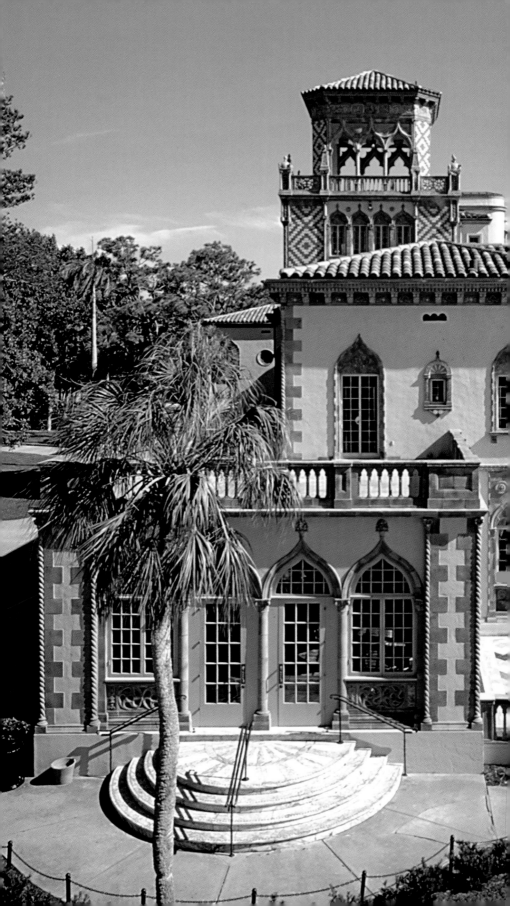

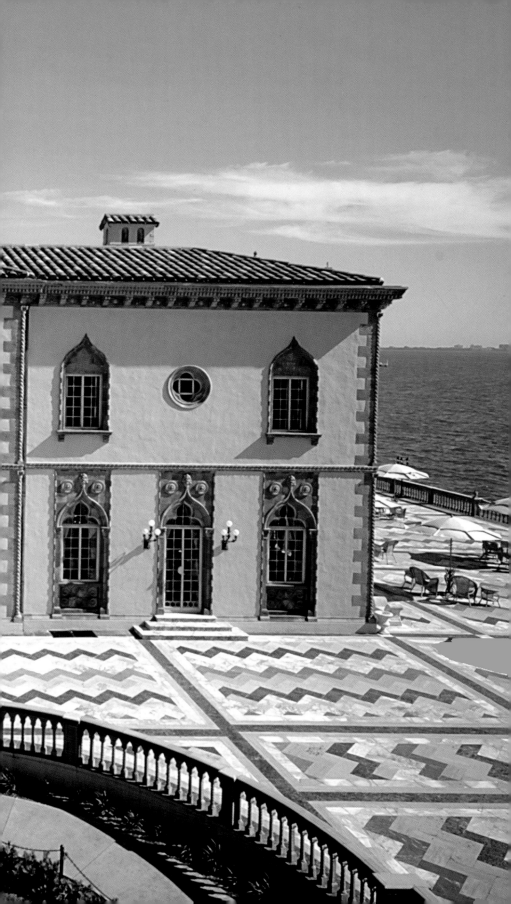

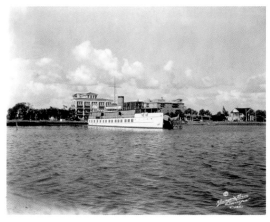

Zalophus off the downtown pier, ca. 1925

John Ringling and
friends on *Zalophus*

Unlike the pretentious and careful copies of European aristocratic rooms that characterized many large American houses of the late nineteenth and early twentieth centuries, the Ringlings' "Venetian" winter home presented the visitor with an exuberant array of styles, evocative of the luxurious, yet relaxed, lifestyle they imagined for Sarasotans. In contrast to the rural and unpretentious old Florida style of the 1895 Thompson house that the Ringlings occupied from 1912 through 1926 on the site, Cà d'Zan was formal and urbane. The lavish decoration conveys an air of elegance with its European furnishings, decorated ceilings, fine paintings, and tapestries on the walls.

Although many great American houses have ballrooms, perhaps none expresses the individual personality of its owners as vividly as the high-spirited and somewhat whimsical example at Cà d'Zan. Adjoining the Court on the north side, this long Ballroom was the scene of many festive evenings. The focal point of the Ballroom is the decorated coffered ceiling. Twenty-two dancing couples painted by William Andrew "Willy" Pogany (1882–1955) decorate the panels between the gilded coffers. Pogany, a Hungarian artist, illustrator, and set and costume designer for opera and theater, was also employed by John Ringling's acquaintance, Florenz Ziegfeld of the Ziegfeld Follies. Pogany painted folk dancers from all parts of the world and called the series *Dancers of the Nations*. Pogany once commented that all the figures, no matter how diverse, were moving to the same rhythm. These panels are on canvas and were completed in Pogany's New York studio before their installation in Cà d'Zan. Pogany also painted and signed the decorative border, where, in the four corners, larger figures illustrate the "Dance in America," from the stately minuet of the

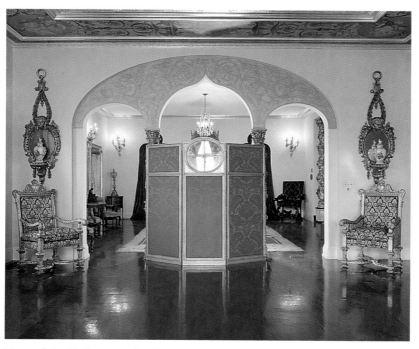

View of the Ballrom to the Reception Room

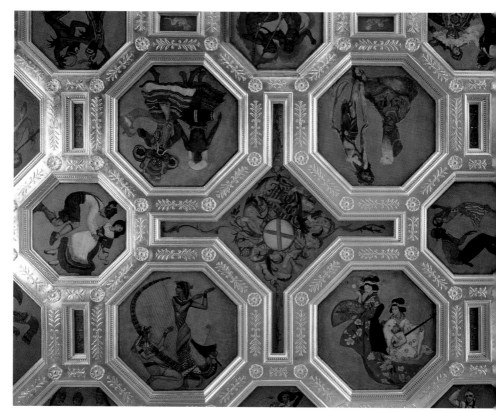

Willy Pogany's Ballroom ceiling, *Dancers of the Nations*

eighteenth century to the tango of the Jazz Age of the 1920s.

The Ballroom floor that extends into the reception area is made of Asian teak. Building materials were chosen carefully and utilized to minimize the fire hazard at what was then a remote northern location in Sarasota. As a result, the floor consists of three levels: a teak surface, wood sub-floor, and fireproof concrete floor.

The Ballroom furniture suite is comprised of a large Louis XV-style settee with matching chairs made after the English style of Daniel Marot (ca. 1700–1705) probably by Philippe Guibert. The furniture upholstery is a modern adaptation of the Genoese cut velvet that was used in the 1890s. Wall sconces by Richard Morris Hunt from the Astor Mansion and gilded torchères light the room. On the south wall there are three eighteenth-century Venetian cut-glass mirrors that were designed to reflect light when only candles lit a room. On the east wall there are two, long Venetian, nineteenth-century Neo-Classical, carved gilt mirrors.

Court/Living Room

While two-storied, central living spaces in most grand houses of the Gilded Age era were—in deference to English style—referred to as "the Great Hall," the Ringlings and their architect, Dwight James Baum, declared that space in Cà d'Zan to be "the Court." The original design of the house—modeled on those found in late Medieval and Renaissance Italy—did, in fact, feature an open-air courtyard. But unlike Venetian homes, which had loggias flush with the walls in the upper stories, Baum placed a cantilevered balcony on three sides, thus achieving an illusion of more human proportions to the interior room while displaying the wealth and status of the owners.

The waterside of the Court has seven pairs of French doors glazed with Lac glass in five colors—amethyst, garnet, emerald, topaz, and sapphire—used throughout the house to give the entire space the desired Venetian effect. The bronze frames surrounding the French doors are decorated with bas-relief figures of creatures from the sea. Half-round awnings on the exterior help control the sunlight, though in late afternoon the glass colors shimmer in the Court and the reflection of the sun glows colorfully on the marble floor.

A steel framework covered with pecky cypress and painted with Venetian-inspired decorations by Robert Webb, supports the glass ceiling of the room. Webb and European decorators under his supervision painted the stencil-decorated ceiling of the Court. These extra decorative details added to the Venetian-like splendor of the Court in particular, and Cà d'Zan as a whole.

The social center of the house was here in this thirty-foot high Court, surrounded by other rooms intended for entertaining, including the Ballroom on one side and the formal Dining Room on the other side. Reproduction Louis XV gilt wood furniture establishes the formal style that the Ringlings wished to achieve for these rooms. Purchased from major auction houses and salesrooms in New York, these pieces

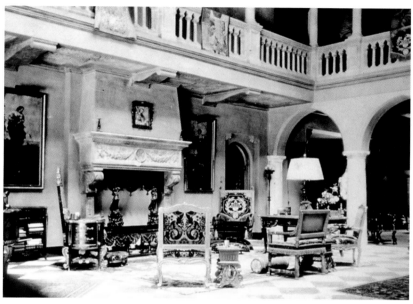

Historic view of Court fireplace, ca. 1927

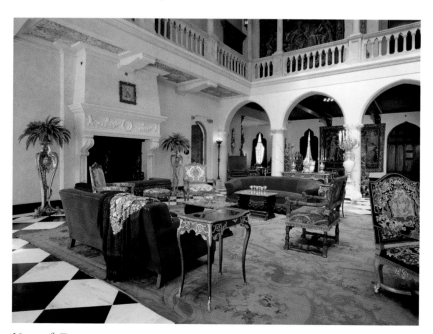

View of Court

filled the home with the stylish splendor popular in the Gilded Age of the 1880s and 1890s.

This was the time when many great mansions on Fifth Avenue were being dismantled and replaced by commercial and institutional structures. Mrs. William Astor's 1895 home, designed by Richard Morris Hunt, belonged to her grandson, Vincent Astor. Mr. Ringling bought several of the more than 100 paintings that covered the walls of the great Astor ballroom-picture gallery. Ringling also purchased the two gilded and embroidered armchairs (created for the Astors by Jules Allard

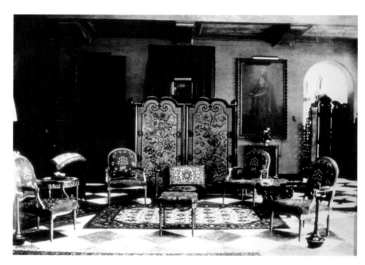

View of Court towards organ, ca. 1927

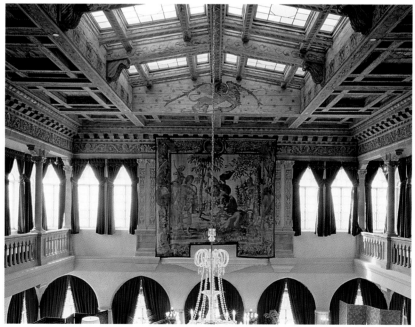

Pecky cypress ceiling

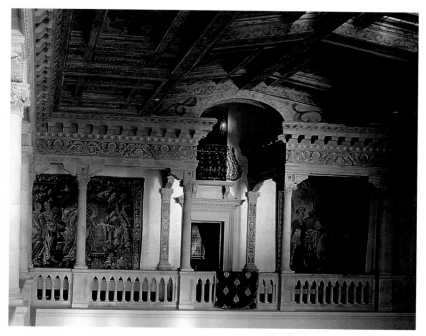

View of the East Mezzanine

et fils of Paris and New York), which are now in the Court of Cà d'Zan.

Another Ringling purchase at the Astor sale was the massive bronze doors from the Fifth Avenue entrance of the Astor Mansion, now in the entrance lobby of the Art Museum, and the complete fittings of several rooms, two of which are reinstalled in the Museum.

At the Astor sale, Ringling also acquired two seventeenth-century Flemish tapestries, which were woven by Gerard van der Strecken and Guillaume van Leefdael. They depict the *Triumph of Caesar over Gaul and Julius Caesar and Pompey in the Harbor of Alexandria.* The latter now hangs over the organ on the south wall of the second story mezzanine to cover—and baffle—the pipe chamber of the great Aeolian, opus 1559 organ—one of ten organs produced in 1924 and called "Duo-Art, residential electro-magnetic." The instrument has 2,289 pipes that range from pencil-size to twelve-inches in diameter, three manual and three ranks. The cork-lined chamber in the basement permits no mechanical sounds to mar the pleasure of listeners.

This was the setting for countless social evenings, afternoon bridge parties, and musical entertainments. In the opposite corner, the 1892 Steinway piano is a custom built "Artist's" instrument, made for a specific player. Mellier made the rosewood case in Hamburg, Germany. The interior and pedals were made in New York.

Next page: View onto the Court

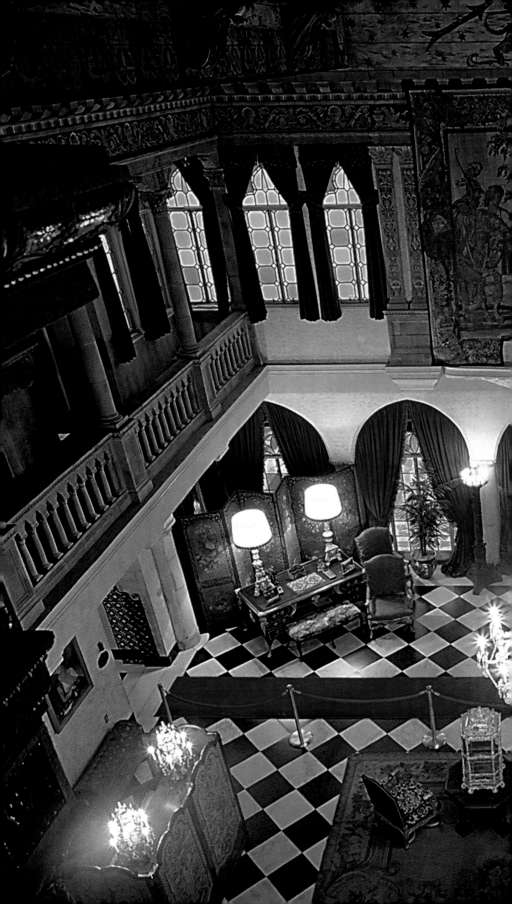

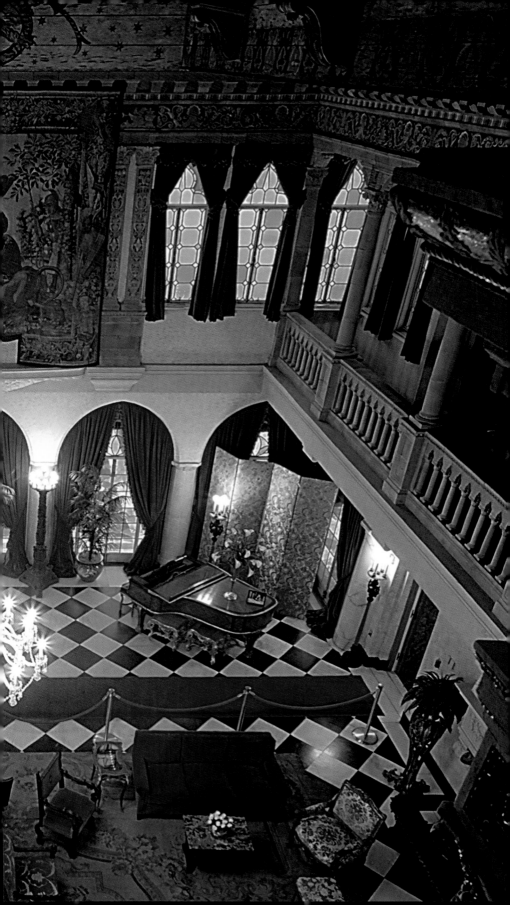

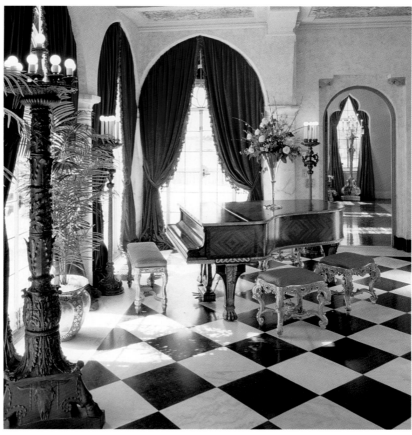

Northwest corner of Court with 1892 Steinway

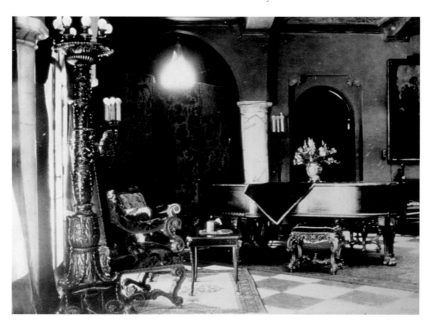

Historic view of Steinway, ca. 1927

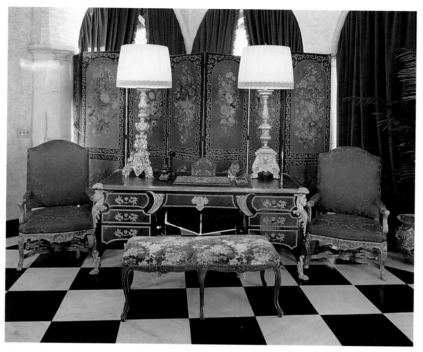

View of southwest corner of Court

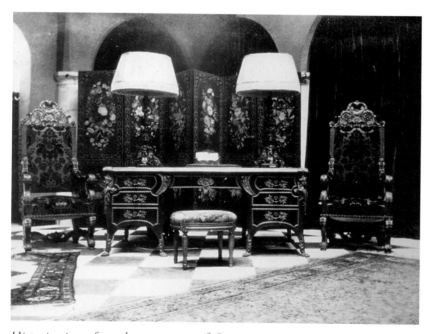

Historic view of southwest corner of Court, ca. 1927

Splendid objects of art from other New York sales add interest to the Court: one is the Bohemian crystal chandelier. It has been attributed to the handiwork of an artisan at the Pierpont Glass Works in New Bedford, Massachusetts. The chandelier was made for the original Waldorf-Astoria Hotel at Fifth Avenue and 34th Street. John Ringling added it to the Court after the hotel was dismantled in 1929 to make way for the construction of the Empire State Building begun in March of 1930. The chandelier is not seen in the earliest photos of the Cà d'Zan taken by Mable Ringling. It does appear in the set of photographs taken by the architectural photographer Samuel Gottscho (1875–1971), commissioned by Baum in 1931 to document the finished and furnished house.

Like the Reception Room, the Court displays a superior Aubusson carpet. In addition to the aforementioned tapestries from the Astor house, three seventeenth-century Flemish tapestries from the Alexander series woven by Jan Leyniers, were purchased by the Ringlings at the Emerson McMillan sale at Darlington House in Mahwah, New Jersey, in October of 1924. One of which, *Alexander Slaying the Lion*, now adorns the upper half of the waterside of the Court.

This impressive space with its lavish furnishings was the area that the Ringlings called the Living Room, and it was made more "livable" by the introduction of comfortable plum-red velvet sofas, flanking a

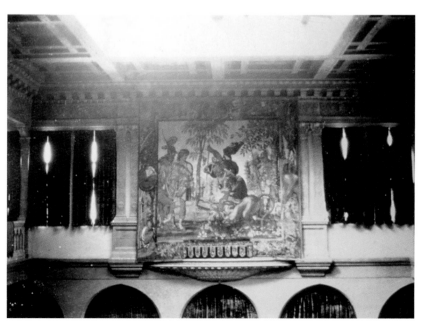

Historic view of Leynier's tapestry, ca. 1927

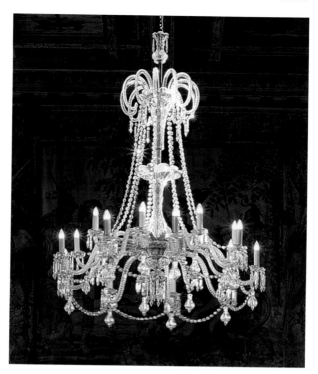

Waldorf-Astoria
chandelier

decorative fireplace. Inscribed on the face of the Italian stone mantle is the cheerful message: "imbre cadente dolce calefieri" (when [rain] showers are falling, it is sweet to be warmed). Yet a pair of fireplace andirons in the style of Florentine Mannerist artist, Benvenuto Cellini were, like the fireplace itself, purely ornamental and were never darkened by fire.

THE INS AND OUTS OF FINE ENTERTAINING

Breakfast/Family Dining Room

Restrained in treatment, the Breakfast Room was used for informal meals and breakfasts. Its wrought iron gate may have kept the Ringlings' dogs from disturbing the guests. The green and clear glass chandelier is a product of Murano, Italy, and complements the Renaissance-style Venetian chairs, initially brown but painted green for Mable Ringling. Footrests for each chair were designed to compensate for the unusual height of the chairs. In the eighteenth century, Venetian women wore voluminous gowns requiring a few extra inches of chair height, hence the need for footrests. The tabletop, made by one of the household servants, rests on antique supports. This tabletop is the only new piece to mix with the array of auction and sale purchases that filled the rooms.

The green color scheme originally served as a setting for two particularly fine paintings, Rosa Bonheur's *Labourages Nivernais* and Jan Davidsz. de Heem's *Still Life with Parrots*, both frequently on display in the galleries of the Museum of Art. As evident in period photographs, a seventeenth-century Genoese work, *Christ Before the Doctors* by Giovanni Battista Langetti, also hung in the room. Another painting the Ringlings place there was the large, seventeenth-century Flemish work by Frans Snyders and Studio (1579–1657), *Still Life with Dead Game and a White Swan*, now in the Museum of Art.

Historic view of the Breakfast Room, ca. 1927

Breakfast room

According to Ringling myth, the image of the eviscerated boar in the Snyders game scene faced the least favored guests. Evidently, John Ringling took delight in the fact that the gruesome sight lessened the enjoyment of the meal by those guests.

The immense Baroque-style console table with the gold veined, black marble top and heavy gilded base, below the Langetti, was acquired by the Ringlings at the same Emerson McMillan sale that offered the Leyniers tapestries. Mable Ringling's historic photographs show the table in the Breakfast Room and not in the more official Dining Room where it was moved since the time of the Ringlings.

Dining Room

Arguably the most opulent room in the house, the formal Dining Room of Cà d'Zan demonstrates the eclecticism of the Ringlings' approach to decorating their winter home. While many clients and designers liked to treat grand interiors as "period rooms," consistently decorated with furniture, paintings, and surface treatments that suggested one specific time in the past (Henry VIII's England was a perennial favorite for dining rooms at the turn of the century), the Ringlings mixed objects and treatments from a variety of periods. Several styles combine to create an air of international splendor.

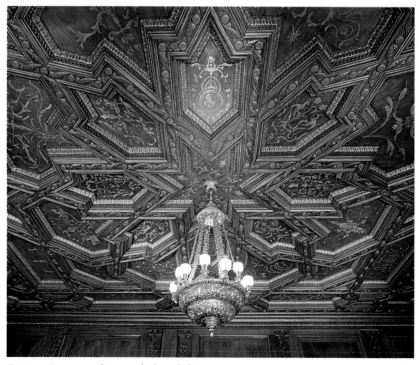

Dining Room ceiling and chandelier

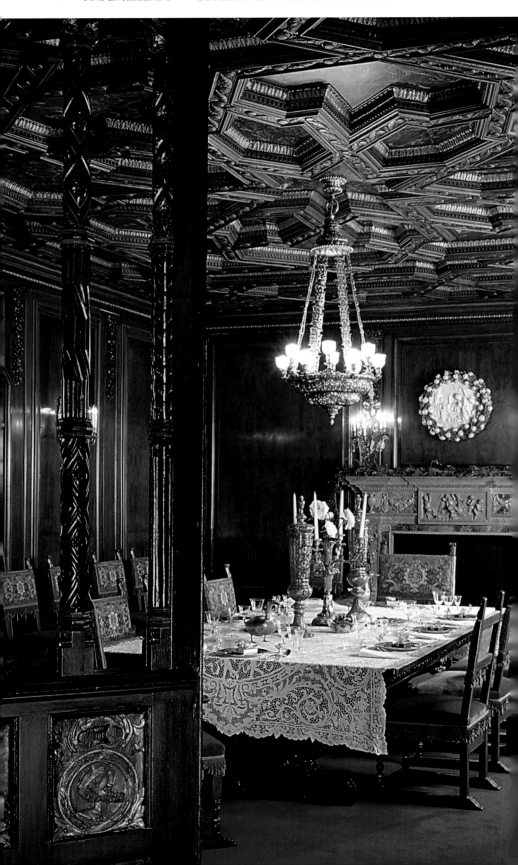

Immensely heavy, carved oak doors are hung on pivots that once had glass panels between the colonettes. The walls are paneled in English black walnut with mahogany trim. While reminiscent of the work of seventeenth-century English master carver, Grinling Gibbons, given the style and the quality, these panels must have come from an American Gilded Age mansion. There is also a high-style carved ornamental marble fireplace from an unknown artist and origin. The overmantel terracotta tondo of the *Adoration of the Christ Child* is attributed to the Italian Renaissance Della Robbia workshop in Florence. The Irish Georgian, gilt-wood pier mirrors are attributed to Francis and John Booker and date to around 1755.

The ceiling combines Moorish and European Renaissance forms with Neo-Classical-style painted decoration. Made of cast plaster to simulate carved wood, at its center is a Maltese cross. The off-white

View into
Dining
Room

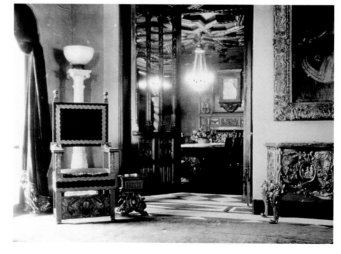

Historic
view into
Dining
Room,
ca. 1927

figures painted by Webb are believed copied, in part, from a collection of plaster casts of historic cameos belonging to Mable Ringling, or, more probably, painted free-hand by Webb from imagination. A silver-plate chandelier signed by E.F. Caldwell & Co. hangs above the table. Silver Caldwell sconces on the walls add light to the dark room.

There are twenty leaves to extend the Parisian Jules Allard et fils table to its full length. Twenty-two Renaissance-style chairs with early nineteenth-century machine-embroidered silk velvet are among the earliest examples of that embroidery process in this country.

Tap Room

A circular hall leads to the Tap Room, adjacent to the formal Dining Room. John Ringling purchased the stained glass panels and wood paneling from the bar of Cicardi's Winter Garden in St. Louis in 1925 and had them altered to fit this private room. One of the most prominent and oddest features in this room is a set of longhorns, which was given to John Ringling on February 1, 1926 by the Texan Amon G. Carter (1879–1955), benefactor to his own museum that carries his name in his native Fort Worth.

Several different styles and techniques of stained glass are apparent. The wall panels establish an autumnal mood with amber-streaked opalescent glass that is framed by grape vines. Shading is defined by

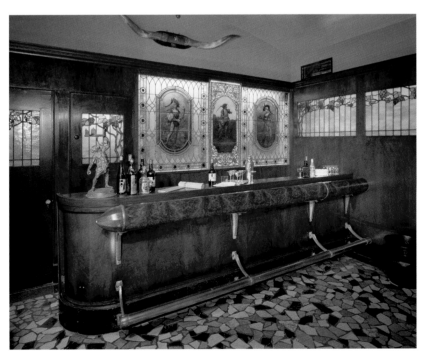

Tap Room

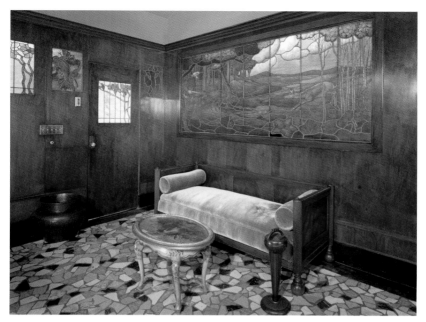

Tap Room

variations in the glass itself, while the lead caming that joins the pieces of glass together also acts visually as a trellis. Back-lit American and Austrian leaded stained glass panels adorn the walls. Facing the bar, the glass is both painted and stained to give greater detail to the scene of a hunter with a crossbow pictured in a landscape setting.

Behind the bar, three panels in an entirely different vocabulary of style and technique continue the overall masculine hunt theme. Opalescent flat and translucent rippled panes are combined with jewel-like insets to provide a frame for the finely stained and painted panels depicting figures. Probably European in origin (signed by C. Brandt), these figure panels demonstrate the artisan's ability to combine the subtle shading and fine detail of panel painting with the inherent luminescence of glass.

The Tap Room was John Ringling's personal clubroom. It is primarily a standing room, but a velvet couch provides seating for those guests, most certainly gentlemen acquaintances, who preferred to sit. The 1920s was the era of Prohibition, and thus a locked closet inside the third floor vault held Mr. Ringling's extensive and illicit wine and liquor collection.

One of nine refrigerators in the house is concealed by doors located behind the bar. A 1924 Kelvinator mechanism outside the house operated all nine units: one in the Tap Room, four in the Pantry and four in the Kitchen. In the circular hall outside the Tap Room, a large

safe held most of Mrs. Ringling's large array of table silver. As part of the estate settlement, the Florida Governor and Cabinet agreed to divide the Ringlings' silver and china. One half was allotted to the North family (Ringling heirs, Ida Ringling North, her daughter Salomé, and her two sons, John Ringling North and Henry Ringling North), while the other half remained in Cà d'Zan for display purposes.

Service Areas and Kitchen

Over one-half of the rooms of Cà d'Zan are service spaces. These areas were the functional core of the large house. The fortunate survival of a complete household inventory, produced in 1938 after John Ringling's death, includes nearly everything in the kitchen from fine china and crystal pieces, to mops and thermos bottles. In addition, a feature in *Country Life* magazine from October 1927 included a description of the kitchen and pantry areas. The inclusion of these service rooms in the magazine coverage suggests that the designers and the Ringlings considered these bright, light, and airy areas to be aesthetically as well as functionally important.

The size and placement of the service areas of Cà d'Zan show that this home was designed to be a place of luxury and comfort. Cà d'Zan

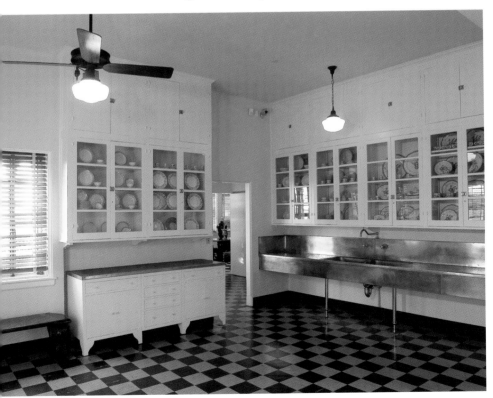

Pantry

was not an immense house with an army of servants. Its moderate size and staff of seven live-in servants, over whom the cook Sophie Collins unofficially supervised, was designed for a couple with no children, large enough for lavish entertaining, but not so vast that it overwhelmed the guests or overshadowed its owners. One purpose of the mansion was to show the wealth and power of Mr. Ringling. The functionality of the service rooms, however, could not be outweighed. The original green color came at the behest of Sophie. She chose the color because she thought it would keep the much used serving and preparation areas cool, or at least seem cool. The green also contained a little arsenic, which would keep to a minimum any of the mettlesome vermin or bugs that are ever-present in any such rooms with the utilitarian demands placed on them for entertaining and meal preparation.

These service rooms, centered around the Butler's Pantry next to the Breakfast Room, tell something of the life of Cà d'Zan. All the conveniences of American housekeeping are present. A hand-crafted sink of German silver (copper, nickel and zinc alloys) was large enough for masses of dishes. The "silver" softens the edges and surfaces minimizing the risk of damage to Mable Ringling's fine china. Cabinets on all sides held the finest gold and bone Lenox china, with a pattern made specifically for Tiffany and Company; Wedgwood China; and cobalt blue Crown Chelsea china. There are also Italian sets of green and yellow Cantagalli glazed earthenware. There were many Tiffany silver serving pieces and a particularly fine set of Tiffany silver tableware in the Persian pattern. Of note is an English set of vermeil fruit dishes with Gorham silver accoutrements. Such large sets of china and serving pieces were needed for Mrs. Ringling's luncheon parties. On one occasion she took both guests and china on a boating party to have lunch at the unfinished Ritz Carlton terrace on Longboat Key.

Servants' Rooms

No known photographs exist that show exactly what the servants' rooms at Cà d'Zan looked like during the Ringlings' lifetimes. Once again, it is fortunate to have a detailed inventory of these rooms that was taken just after John Ringling's death in 1936. From this record, it is known that the rooms contained simple metal or wooden furniture that consisted generally of twin or three-quarter beds, dressers, and chairs. Interestingly, according to the inventory, all the rooms contained depictions of work scenes, many of which belonged to a set of historicizing prints of milkmaids, fishermen, and other laborers entitled *London Cries*. It is not known if the Ringlings purchased the prints with the decoration of the servants' quarters in mind.

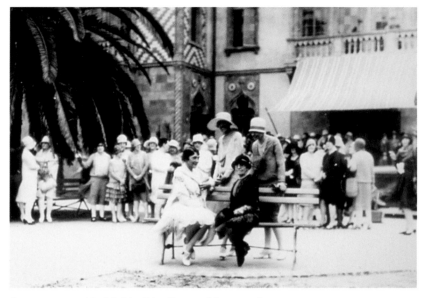

Lawn party with Mable Ringling and her mother

THE INNER SANCTUM

T he first floor of the mansion was the public stage in the life of the Ringlings. In contrast, the second floor was the private more inti-mate domain of both John and Mable Ringling and their guests. This floor contains two personal bedrooms, each with the decorative taste and personalities that reflects that of their inhabitants, the Ringlings. The other guestrooms on this floor are also distinctive in their indi-vidual decors, which are based on color schemes determined by Mable Ringling (pink, gold, green, blue, and an orchid and pale-green room with Rococo-style furniture that adjoins Mrs. Ringling's dressing room that was principally used by her sisters when they visited).

The Grand Staircase

Even though John Ringling equipped his Cà d'Zan with the first Otis electric elevator ever installed in a private home in Florida, he knew that the central, dramatic effect of an elaborate sweeping staircase was vital to the Beaux-Arts house. The cascading marble steps allowed the host and hostess to make grand entrances, while also providing a graceful sequence of transitional spaces between the public rooms of the first floor and the more private realm of the second.

The central stairway with Carrara white marble steps and a Siena gold marble handrail, winds around the elevator shaft. The entrance to the elevator is a carved stone doorframe with a frescoed lunette over

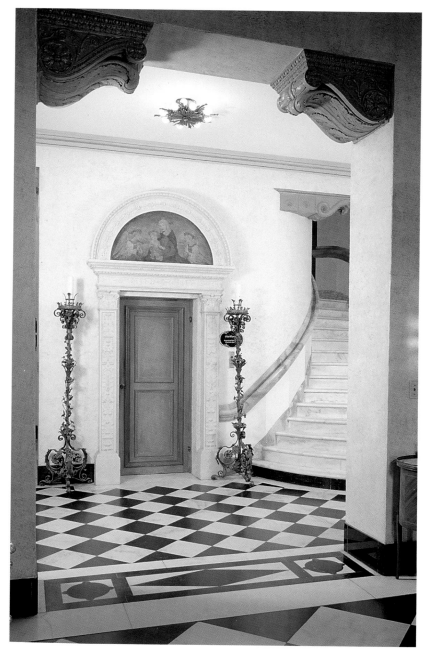

The Grand Staircase

the door, depicting the Virgin and Child with two angels. Partway up the stairs, a small flight branches off to Mr. Ringling's private office.

John Ringling's Office and Exercise Room

It has been said that John Ringling chose the southwest corner room for his home office so he could look across the bay and gauge the

progress of his building projects on Longboat Key. While Mr. Ringling undoubtedly attended to business matters here, it is likely that he also used this room as a private study where he read from his collection of art books and rare editions in order to sharpen his collector eye. The adjacent Exercise Room, an unpretentious space with a Florida coquina shell floor, was purely utilitarian. A massage table and a vibrator-belt, reducing-machine were the only exercise equipment. A shower in the adjoining bathroom was a novel innovation to south Florida.

John Ringling's Bedroom

John Ringling's bedroom is furnished with a set of thirteen pieces of French Second Empire furniture made by Antoine Krieger (1800–1860) in Paris in the early 1850s. A similar set belonged to Napoleon III (1808–1873) and is now at Malmaison near Paris. John Ringling paid $35,000 at auction for the mahogany furniture, which is heavily ornamented with gilt bronze ormolu. The furniture-making firm of Maison Krieger was run by Antoine and his brother Nicolas. They were the premier furniture maker in Paris from the 1820s through the 1850s, after which their sons-in-law took over the company and changed the name.

The door and window surrounds in the room are decorated with gold leaf. On the ceiling is a Dutch eighteenth-century oval canvas by Jacob de Wit (1695–1754), *Dawn Driving Away Darkness*, 1735. Robert Webb initially painted the canvas ceiling to extend the clouds from the central oval outwards to cover the entire ceiling, wall-to-wall. Later, almost the entire painting was removed except for the central section by De Wit for which Webb made a plaster oval frame. Today, remnants of Webb's extended ceiling can be seen above the bookcase on the waterside of the room, just before one enters John Ringling's home office.

One of Ringling's early purchases, a seated portrait of Napoleon's sister, Pauline Bonaparte Borghese, painted by Louis Benjamin Devouge (1770–1842) in the 1820s, hung on the wall opposite the beds. Ringling

Napoleon III-style furniture by Antoine Krieger

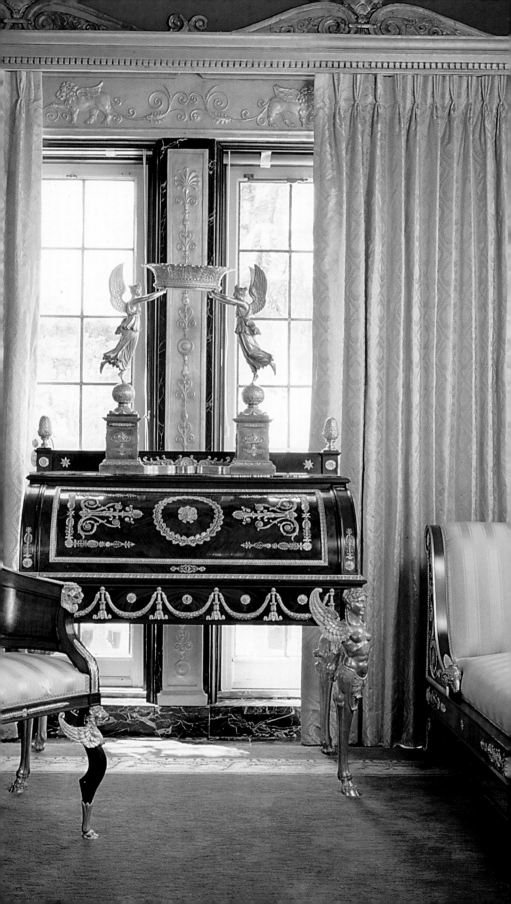

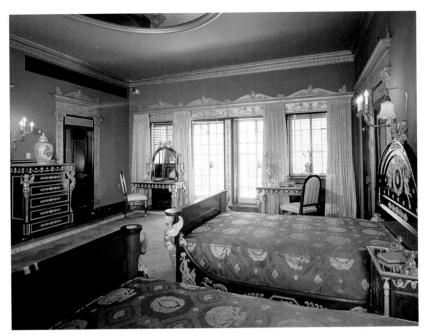

John Ringling's Bedroom with Napoleon III-style furniture

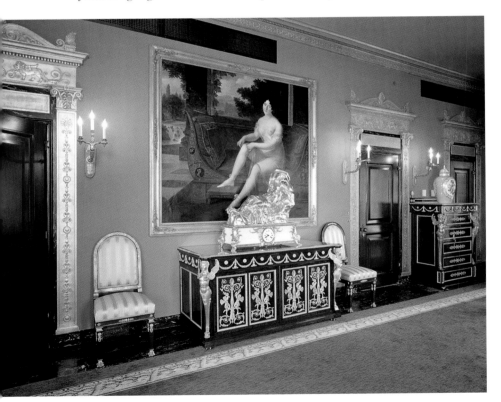

John Ringling's Bedroom with Devouge's *Portrait of Pauline Bonaparte Borghese* and the *Sleeping Ariadne* Clock from the Henry Hilton mansion, New York

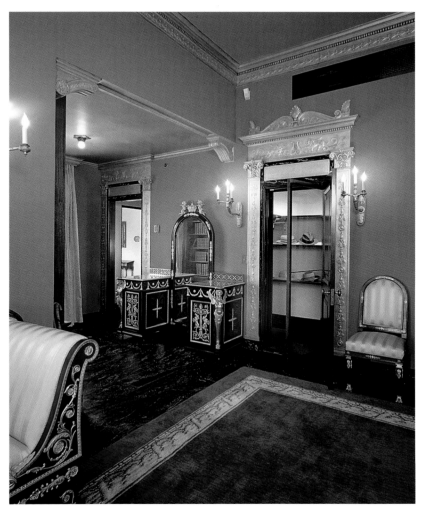

View to John Ringling's closet and dressing area

purchased this picture in 1916 from the Sinton-St. Nicholas Hotel in Cincinnati while he was staying there. Between the two beds hung a small, late sixteenth-century painting, *Portrait of Jacopo di Lusignan, King of Cyprus*, by an unknown Venetian painter.

The interior loggia on the east side of the room has a Pompeiian-style painted ceiling; Mrs. Ringling's room also opens onto this loggia. From this vantage point, there is a dramatic view of the approach drive-way and the rose garden; on the west side, a book-lined alcove offers an even more impressive view of Sarasota Bay. According to the inventory of Cà d'Zan, John Ringling's bedroom housed part of his impressive library of art books. These books are important evidence of Ringling's taste and knowledge of the art he collected, and would later become the core of the Library in the Museum of Art.

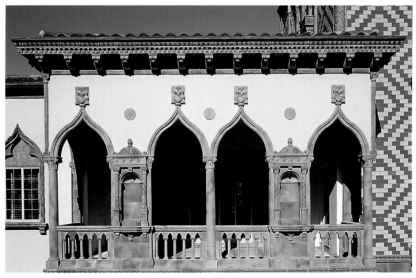

John and Mable Ringling's private loggia

John Ringling's Bathroom

Mr. Ringling was exceedingly proud of his Siena marble-walled bathroom, with its gold-plated fixtures and a large tub carved from a single block of gold Siena marble. Architect Baum, knowing his client's love of rich surroundings, provided this elegant symbol of a gentleman's wealth, sure of its appeal to the owner of Cà d'Zan.

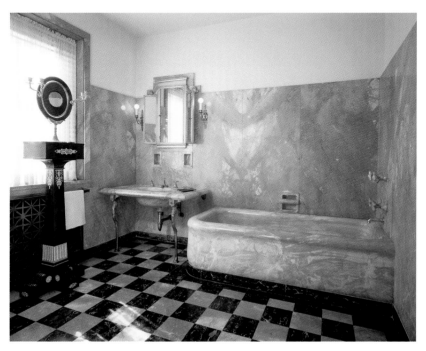

John Ringling's Bathroom with his Siena marble tub

Mable Ringling's Bedroom and Dressing Room

Mable Ringling's fine personal taste is especially evident in the room decorated and furnished for her pleasure. The walls are covered with gray wall canvas, hand-painted in pencil stripes of green, gray, and red. A suite of Louise XV-style furniture, interpreted in the late nineteenth century, retains the curved forms of the Rococo. This set, made by François Linke (1855–1946), is sandalwood with tulipwood marquetry and is set off with exquisite bronze ormolu. At the turn of the twentieth century, Linke was the most prestigious maker of furniture and produced the finest pieces in Paris, which were much sought after by the aristocracy. All the pieces, with the exception of Mable Ringling's desk, have marble tops. Mrs. Ringling had a particular interest in fine fabrics, including laces, embroideries, velvets, petit point, tapestry, and brocades. She also paid strict attention to the passementerie (ornamental braided trims and fringes) found on her finely upholstered furniture. Extant receipts indicate that she purchased extraordinary fabrics from Italy using her husband's art dealer, Julius Böhler, as an intermediary. Many of these fragile fabrics, some purchased as antiques in the 1920s, have been lost over the years and those that survive are extremely delicate. Mable Ringling collected patterns of lace from various places, notably Brussels, Venice, and Ireland. One small remaining pillow has a lace cover made by Mrs. Ringling. The

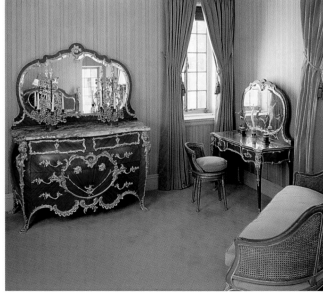

Mable Ringling's Bedroom furniture
by François Lincke

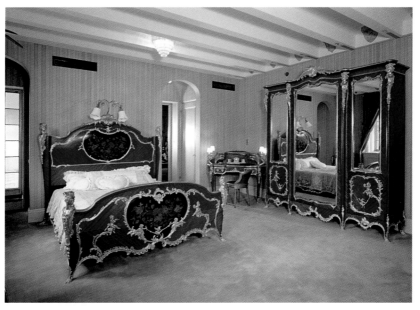

View of Mable Ringling's Bedroom

Mable Ringling's Bedroom with her bedspread of collected lace

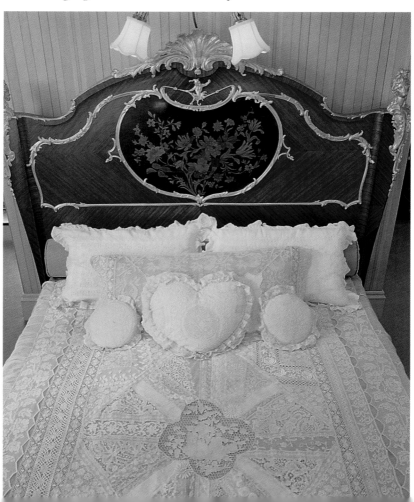

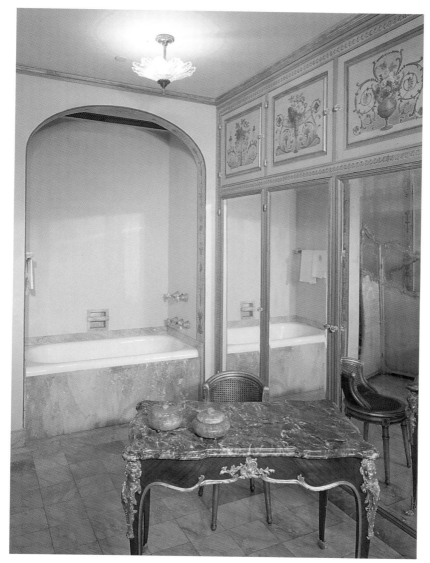

Mable Ringling's Dressing and Bathroom

bedspread contains seventeen different lace patterns and covers a mattress from the Ritz Carlton Hotel in New York.

This elegant room has some puzzling features. For example, Robert Webb decorated the ceiling beams near the walls with unexplained punctuation marks. Further, Mrs. Ringling's dressing room is richly painted with Pompeiian-style designs, also by Webb. It was in this dressing room that Mrs. Ringling stored her personal linens, monogrammed "MBR." Though Mrs. Ringling's first name was Armilda, she chose to be known as Mable.

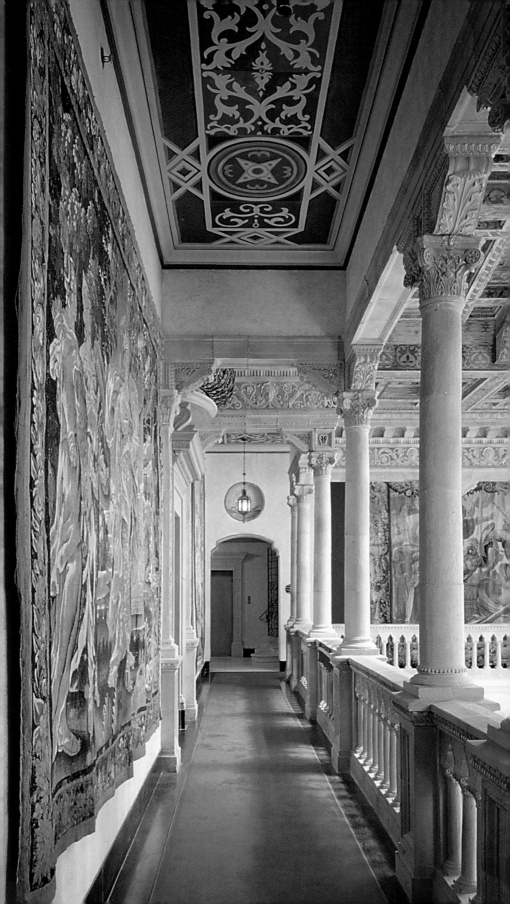

STAYING OVER

Guest Bedrooms

Although many celebrities stayed at Cà d'Zan during the Ringlings' time, we have no historic photographs of the rooms in which they slept. Based on the inventory of the house made shortly after John Ringling's death, items described in the list of contents of each room have been matched to objects currently in the collection. This allows a reasonable re-creation of the Guest Rooms.

There are five Guest Rooms on the second floor, and one on the fourth floor near the top of the tower. The principal Guest Room is on the second floor over the east door, and adjoins Mrs. Ringling's boudoir. The room is furnished in the French Rococo-style with furniture made in the early twentieth century.

This room and each of the other guest rooms have some unusual features requested by Mrs. Ringling. Inside each closet and on the doors and interiors of the bathroom cabinets are exotic scenes, birds, sailboats, and figures painted by Robert Webb. Mable Ringling wished this added touch to amuse and surprise her guests. The doors to the Guest Rooms that enter from the mezzanine balcony have canvas-covered panels on

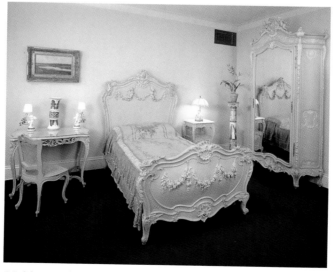

Mable Ringling's Guest Room

East Mezzanine

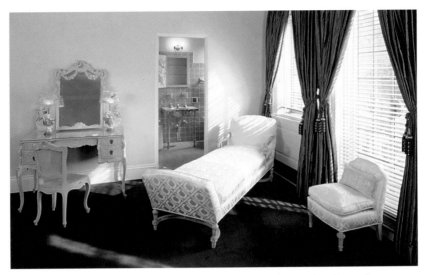

Mable Ringling's Guest Room and Bathroom with art tiles from the American Encaustic Tiling Co.

which Arcadian scenes are painted. The painter credited with the work was Keppa Buck, brother of Frank Buck, the Texas animal trapper-collector and jungle adventurer, who provided animals to zoos, circuses, and private collectors.

Florida homes in the 1920s commonly used Spanish, Italian, or Mexican floor tiles, particularly in upscale homes. Two of the

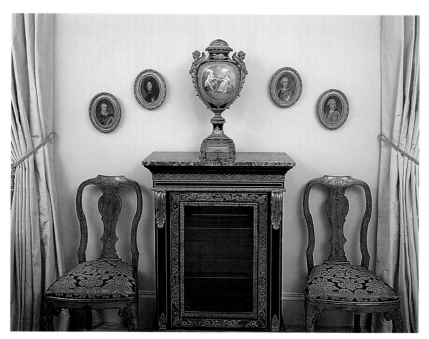

Pink Guest Room

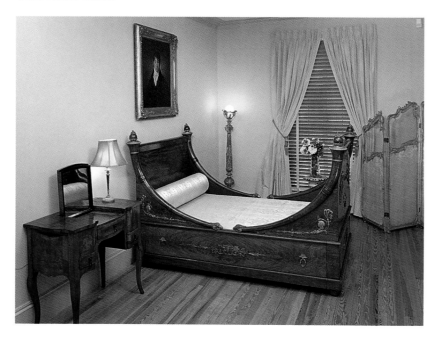

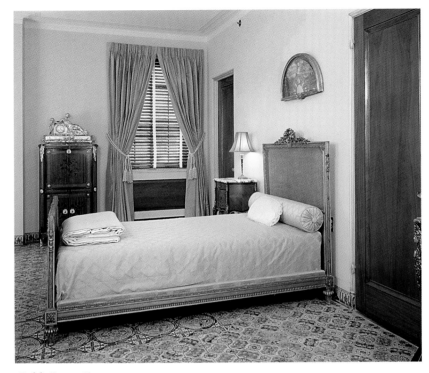

Gold Guest Room

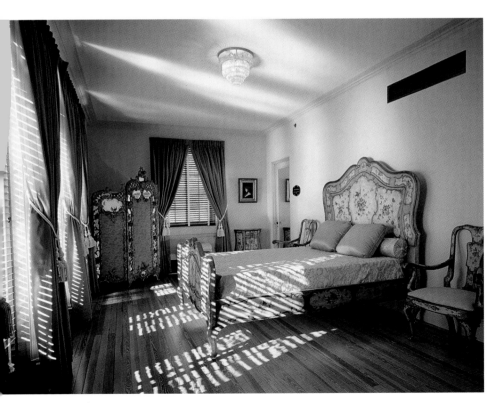

Blue Guest Room

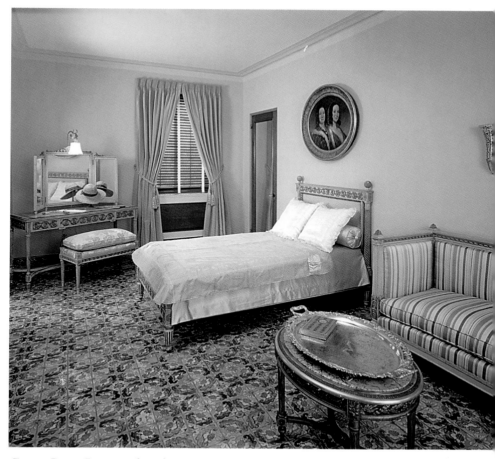

Green Guest Room and Bathroom

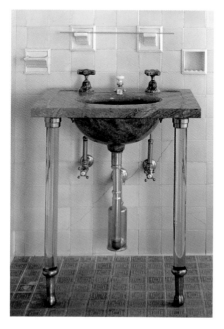

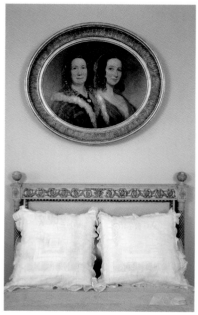

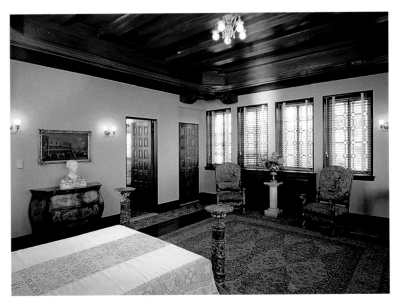

Fourth floor Guest Room

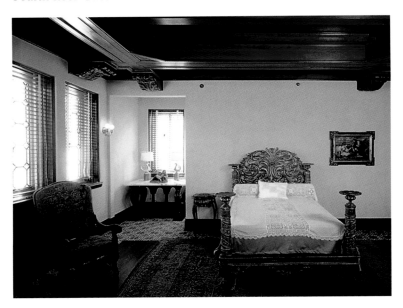

north-side guest rooms have glazed tile floors; the other two have wood floors that were usually covered by carpets. Each of these rooms is modest, decorated and furnished with individual color schemes: pink, gold, green, and blue. The accompanying bathrooms for each room follow the color décor of the room. For example in the Gold Guest Room, the bathroom is outfitted in accents of black and golden yellow. Also in the Gold Guest Room is a fine, marquetry and gilt bronze ormolu secretary and bookcase set made by Jansen in Paris.

CARNIVAL PARTY WITH ALL OF ITS PARTS

Game Room

Originally planned as an attic, the Game Room on the third floor of Cà d'Zan was transformed into yet another informal center for pleasurable pursuits. The room occupies half the east front and the whole north side of Cà d'Zan. Here, the artist Willy Pogany was given free reign. His painted ceiling figures represent the entire Ringling household, including John and Mable in Venetian Carnival costume dancing among their pets. Mable Ringling's Miniature Pinschers cavort around her, while John Ringling's beloved German Shepherd, Tel, takes a more dignified stance. The four birds, Mrs. Ringling's white Cockatoo, Laura (said to be bad-tempered); Jacob, the gray African parrot who could speak only in German; and two more colorful parrots and several finches complete the domestic menagerie. Other fanciful figures join in the spirit of Venice at Carnival time.

The Game Room

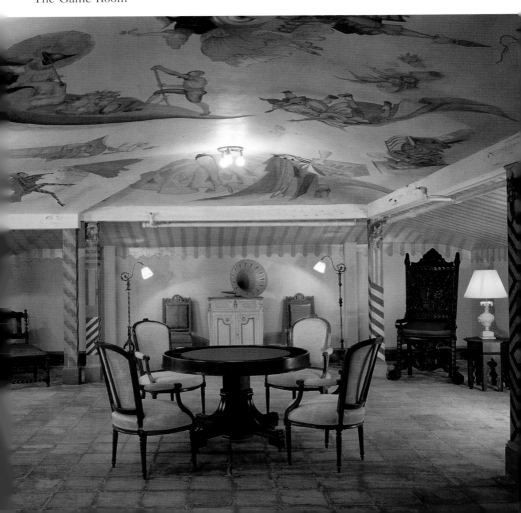

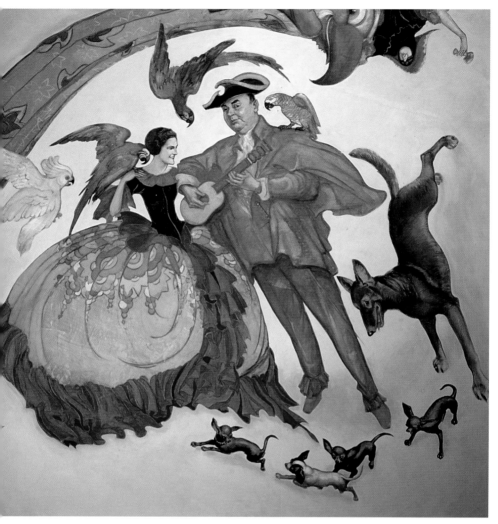

Game Room ceiling, John and Mable Ringling in Carnival costume

A most unusual feature, the many pecky cypress posts under the roof help support the large size of the room. Each post is decorated with the masks of the Venetian Carnival and the figures of the *commedia dell'arte*, well known in the Italian theater. On the ceiling near the doorway, a smiling Pogany painted himself tiptoeing from the finished murals, leaving the room to be enjoyed by the household and its friends.

A light blue gramophone with a decorated, morning-glory horn provided music. A few of the records still exist that document the musical tastes of the Ringlings. The billiard table was initially in the Charles Ringling home on the adjoining estate. However, it fits the décor of Cà d'Zan with supports carved as the winged lions of Venice.

Interestingly, in 1947 a visitor recognized a poker table as one of three made for Frederick Kuser, a New York brewery and sport team owner. Of the three tables crafted by Parisian artisans, two remain in the Kuser family and the third was a gift to John Ringling. Until it was rediscovered in 1947, its whereabouts had been unknown.

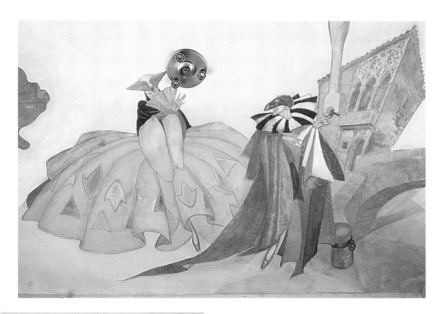

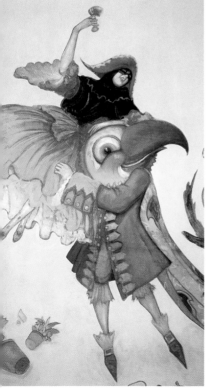

Game Room ceiling details and painter Willy Pogany

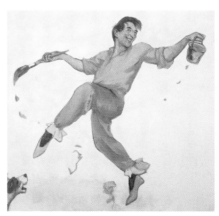

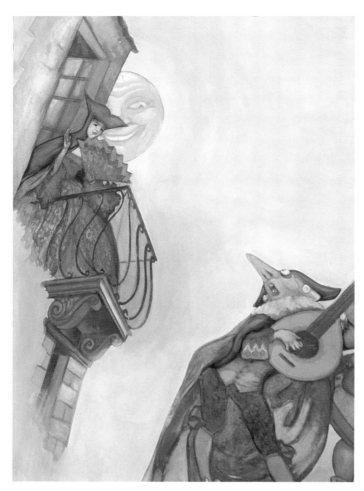

Game
Room
"The
Serenade"

Vault

Like many large homes, Cà d'Zan contained vaults for storage of valuables, such as silver and jewelry. While many assume that such safekeeping indicated a lack of trust between employers and staff, the vaults served several practical purposes. They not only enabled the housekeeping staff (as well as the owners) to keep track of small but costly items, they also saved the cost and trouble of transporting valuables off-site during the Ringlings' summer-long absences from Cà d'Zan.

The vault adjacent to the Game Room was put to a very timely purposeful use. The Eighteenth Amendment to the United States Constitution, ratified in 1919, prohibited the manufacture or sale of alcoholic beverages. While poorer folk relied on remote stills in the pinewoods for their uncertain supplies, Sarasota's elite did not have to suffer during the "dry" episode. Traffic through Sarasota late at night

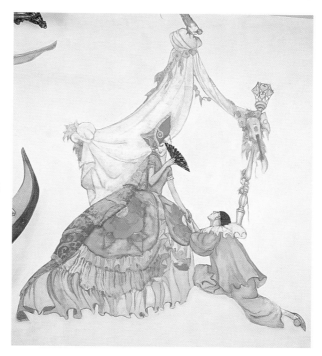

Game Room
"The Entreaty"

in the mid 1920s was a procession of large, powerful cars racing from Miami to Chicago carrying bootleg liquor. Cà d'Zan was well supplied by a neighbor who controlled the flow of bottled goods for special friends. The Game Room vault maintained a dark storage area for Mr. Ringling's private stock of wine and liquor. The bottles were stored in a closet within the vault.

CLOSING

For a time John and Mable Ringling had nearly everything they wanted. Once the architect and craftsmen finished their work, the grand life in the Venetian palazzo began in earnest. From the beginning, the house was indeed a showcase—unrivaled and unique in Sarasota—with public rooms that served as venues to display the many Ringling treasures brought from Europe or purchased at New York auctions. Yet, this luxurious house also presented a challenge to Sarasota; its owners were circus people, an exotic genre in this sober community.

John and Mable Ringling were also rich and important celebrities, newsworthy locally for Mr. Ringling's increasing activity as a major landowner and developer in Sarasota, and nationally as a railroad owner, oilman, and rancher. Cà d'Zan was finished and occupied at

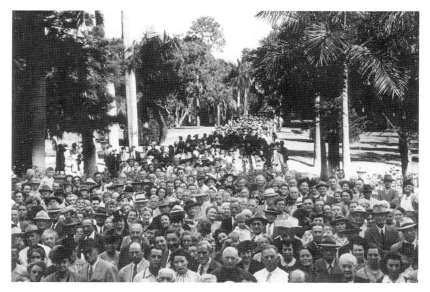

Public opening of Cà d'Zan with over 10,000 visitors, December 15, 1946.

about the same time Ringling's Florida island empire was being marketed and exploited as a fashionable Gulf Coast resort. Social events there included supporters and useful local connections, as well as Mr. Ringling's business, financial, and celebrity guests.

Moreover, Cà d'Zan was Mable Ringling's theater, its sets arranged for grand dramatic effect. Mrs. Ringling was beautiful, outwardly poised, and an ideal wife for her imposing husband. She was equally at ease with Sarasota's elite as she was with celebrities from the world of finance, railroads and hotels, and the figures from entertainment and theater in New York.

The social role of Cà d'Zan was brief, however, for it lost much of its social momentum upon the untimely death of Mable Ringling at age fifty-four on June 8, 1929. John Ringling lived until 1936, though much of his time was spent managing the challenging financial crises that threatened all American businesses during the Great Depression.

Cà d'Zan continues to embody the lasting monument of the lives of John and Mable Ringling in Sarasota. The house remains a preeminent jewel of the west coast of Florida and stands as a signature of the great legacy of fine art and culture that the Ringlings envisioned on the shores of Sarasota Bay.

SELECT BIBLIOGRAPHY

Baum, Dwight James. *The work of Dwight James Baum, architect/ with a foreward by Harvey Wiley Corbett... & an introduction and commentary text by Matlack Price.* New York: W. Helbrun Inc., 1927.

Binney, Marcus. "Cà d'Zan, Sarasota, Florida." *Country Life* (October 28, 1976):

Böhler, Julius W. "John Ringling: Builder and Collector." in *The John and Mable Ringling Museums,* Sarasota, Florida: The John and Mable Ringling Museum of Art, 1949, pp.11–17.

_____. "Ringling: Collector and Builder. in *The Ringling Museums: A Magnificent Gift to the State of Florida.* Sarasota, Florida: The John and Mable Ringling Museum of Art, 1952, p. 15–22.

Buck, Patricia Ringling. *The John and Mable Ringling Museum of Art.* Sarasota, Florida: The John and Mable Ringling Museum of Art, 1988.

Ceo, Rocco J. and Joanne Lombard. *Historic Landscapes of Florida.* Miami, Florida: Deering Foundation: University of Miami School of Architecture, 2001.

Clarke, Gerald. "Historic Houses: Florida's Cà d'Zan: Circus Magnate John Ringling's Venetian-style Palazzo." *Architectural Digest* 59 (October 2002): 206–215.

De Groft, Aaron, Mark Ormond and Gene Ray. eds. *John Ringling: Dreamer, Builder, Collector: Legacy of the Circus King.* Sarasota, Florida: The John and Mable Ringling Museum of Art, 1996.

De Groft, Aaron H. "John Ringling *in perpetua memoria*: The Legacy and Prestige of Art and Collecting." Phd diss., Florida State University, 1999.

"Developing a regional type with a particular reference to the work in Florida of Dwight James Baum." *American Architect* 130 (August 20, 1926): 144–148.

Folsom, Merrill. *Great Mansions and Their Stories.* New York: Hastings House, 1963.

Frankfurter, Alfred M. "John Ringling's Greatest Show." *The ARTnews* 19 (1950 annual): 3-11.

Hack-Lof, Françoise, Teresa A. Koncick, and Linda R. McKee. *Cà d'Zan: The Ringling Winter Residence.* Sarasota, Florida: The John and Mable Ringling Museum of Art, 2003.

Handy, Amy. *American Castles: A Pictorial History.* Philadelphia: Courage Books, 1998.

Maher, James. *The Twilight of Splendor: Chronicles of the Age of American Palaces.* Boston: Little, Brown and Company, 1975.

Matthews, Kenneth and Robert McDevitt. *The Unlikely Legacy: The Story of John Ringling, The Circus, and Sarasota.* Sarasota, Florida: Aaron Publishers, Inc., 1979.

"Mr. John Ringling: Canivora to the General." *TIME* 5 (April 1925): cover and 15.

Murray, Marian and A. Everett Austin, Jr.. *The House that John and Mable Ringling Built: A Short Guide to the Ringling Residence.* Sarasota, Florida: The John and Mable Ringling Museum of Art, 1951.

"A Palace of Art in a Small Town in Florida: John Ringling's Art Museum at Sarasota." *The New York Times,* April 13, 1930, Rotogravure Picture Section, Section 7, p. 2.

Ringling, Alfred. *Life Story of the Ringling Brothers.* Chicago: R.R. Donnelley & Sons Company, 1900.

Sears, Roger Franklin. "A Venetian Palace in Florida." *Country Life* 52 (October 1927): 35–41.

Scheller, William G. *Barons of Business: Their Lives and Lifestyles.* Hugh Lauter Levin Associates, Inc., 2002.

Walk, Deborah W. *A Guide to the Archives of the John and Mable Ringling Museum of Art, The State Art Museum of Florida.* Sarasota, Florida: The John and Mable Ringling Museum of Art, 1994.

Weeks, David C. *Ringling: The Florida Years, 1911–1936.* Gainesville, Florida: The University Press of Florida, 1993.

Wernick, Robert. "The Greatest Show on Earth Didn't Compare to Home." *Smithsonian* 12 (September 23, 1981): 62-71.

Williams, Henry Liones and Ottalie K. Williams. *Great Houses of America.* New York: Putnam, 1966.

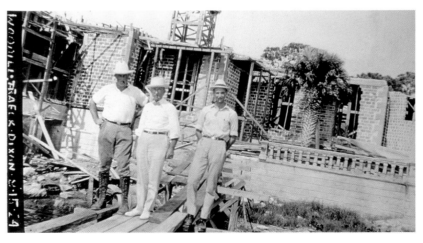

Harold Woodill, an unidentified man "Traeck," and Lymon Dixon at the Cà d'Zan construction site, August 15, 1924. It is Woodill's photos that document the building of the Ringling Mansion.

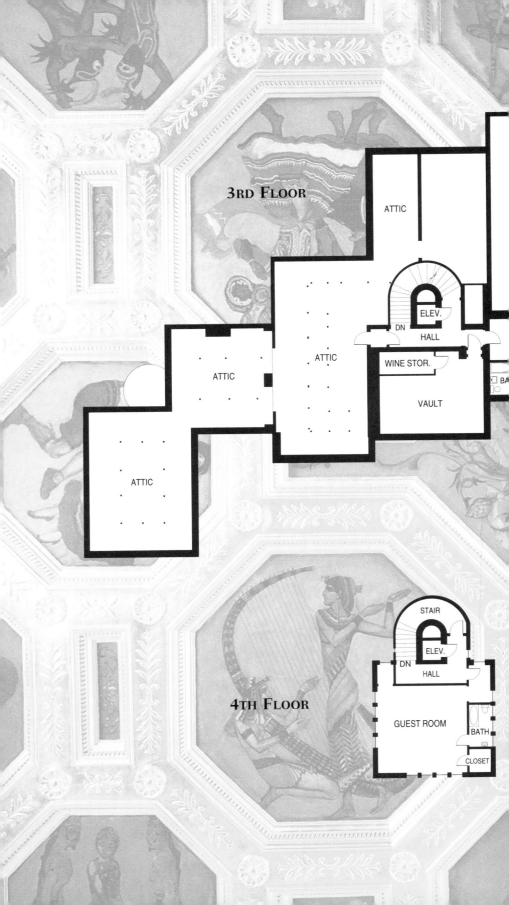

3RD FLOOR

ATTIC

ATTIC

ATTIC

ATTIC

DN

ELEV.

HALL

WINE STOR.

VAULT

BA

4TH FLOOR

STAIR

ELEV.

DN

HALL

GUEST ROOM

BATH

CLOSET